Creative
Authenticity

16 Principles to Clarify and

Deepen Your Artistic Vision

•

I A N R O B E R T S

Published by Atelier Saint-Luc Press
P.O. Box 1082
Fairfield, IA 52556
USA

Library of Congress Cataloging-in-Publication Data

Roberts, Ian, 1952-
 Creative authenticity : 16 principles to clarify and
deepen your artistic vision / Ian Roberts
 p. cm.
 LCCN 2003096034
 ISBN 0-9728723-2-9
 ISBN 13 978-0-9728723-2-4

 1. Creative ability. 2. Aesthetics. 3. Creation
(Literary, artistic, etc.) 4. Self-actualization
(Psychology) 5. Self knowledge in art. I. Title.

BF410.R63 2004 153.3'5
 QB103-700567

Book design: Bluebird Graphics
Photographs: Ian Roberts
Printed in the United States of America
10 9 8 7 6 5

Acknowledgments

Abook like this is the compilation of personal experience and conversations jumbled together with a lot of reading over the years. I have no doubt left out names of people who should have been mentioned. I thank them for their now anonymous help. Those who do need thanking are all the authors whose books I've quoted. I'd also like to thank Janet Sussman, who first suggested the idea, Coral Scranton, Dan McCaw and Tom Darro. Victoria LeBlanc for her editing, Jocelyn Engman for her final, eagle-eyed proofing and Shepley Hansen for taking my mock-ups and making them better than I'd envisioned.

To my parents.

The difficulties artmakers face are not
remote and heroic, but universal and familiar.
—David Bayles and Ted Orland, *Art and Fear*

•

An artist learns by repeated trial and error,
by an almost moral instinct, to avoid the merely
or the confusingly decorative, to eschew violence
where it is a fraudulent substitute for power,
to say what he has to say with the most direct
and economical means, to be true to his objects,
to his materials, to his technique, and hence,
by a correlated miracle, to himself.
—Irwin Edman, *Arts and the Man*

Table of Contents

Foreword

Two years ago, to a packed room of over two hundred people in a small-town public library, I gave a talk on "Creative Authenticity." At the end of that talk, the simple feedback from the audience was that I should publish it in a book. They felt the talk was something artists needed to hear.

The people who came to that lecture were artists and writers, or had been, or wanted to be. And the confusion of myths, fears and "shoulds" surrounding their creative process was readily apparent.

I have expressed the ideas from that talk here, elaborating some and adding several new principles. They are not intended to be "answers." As often as not, I'm posing questions, suggesting possibilities. Since these ideas are all based on my personal experience, there are some answers that work for me, at least for now. Whether they are right for you is something you'll have to find out.

If in the process of reading this book you find renewed inspiration to give expression to what hovers—so tantalizing

and elusive—just beneath the grip of the conscious mind, as well as some insight into how you might go about doing that, then, as they say, this book will have been worthwhile.

> — Bellagio, Lake Como
> April, 2003

Introduction

This book is for artists and writers and anyone else engaged in the difficult but personally fulfilling path of creative expression. It's for those who are actually doing it, one way or another.

My hope is that this book will provide insights, tools or ideas to make the journey deeper, perhaps more conscious, and maybe even easier.

A friend reading the manuscript suggested the principles should be more active: Search for Beauty, rather than Searching for Beauty, for example. And that there could be an action step at the end of each principle.

As it happens, that is precisely what I don't want this book to be. In raising questions and possibilities, a quick call to arms would probably be both superficial and counterproductive.

I'm not sure this book is for people who want to create, but don't. It seems to me in the end, as far as expressing yourself is concerned, you just have to plunge in, fears and all. There is something courageous about it. If a person is too timid even

to start, I'm not sure what it would take to get that person started. I'm not a big believer in the books and courses that advocate creativity rituals, altar making and mask making to get unstuck and get started. Maybe that stuff works. I don't know. They just seem like more strategies to avoid getting on with it. This, then, is a book for people who are in the thick of the creative struggle.

Desire is the message that you have something to say. I have tried to address this as a coming to terms with your own very personal take on that desire—its authenticity. Each principle rests on several basic assumptions regarding the need for authenticity:

1. In the end there is no other kind of art but art that is authentic.

2. I could have used the word "originality," rather than authenticity, if the word's root in "origin," as in, from the depth or source, is recognized. However, the word implies a certain newness, "never done before," that authenticity does not, and art in general does not need, in order to be deeply personal.

3. Something that is authentic "rings true" for us. It comes from an inner truth. We draw from a source that is inner directed rather than outer directed, to use Abraham Maslow's definition of self-actualization.

4. Work that is authentic has a sacredness to it. It may be a way—a small but at least personal way—out of a social dynamic that is all economics, consumerism, greed and disregard for inner life. "Science" derives from the root word meaning "to separate." Our cultural worldview has been deeply influenced by that separation. Anything that we come to authentically in our artistic expression demands a personal inner synthesis. It is experience and insight won firsthand. The more we assimilate our "experience" from the advertising/media/consumer/government perspective the less authentic it will be.

5. Most of what we express creatively is prelinguistic. The deeper insights are obviously coming from somewhere. They are not logically structured in the mind, but it may take logic to get them expressed.

6. Ultimately, it doesn't matter to the world if you paint or dance or write. The world can probably get by without the product of your efforts. But that is not the point. The point is what the process of following your creative impulses will do for you. It is clearly about process. Love the work, love the process. Our fascination will pull our attention forward. That, in turn, will fascinate the viewer.

I'm a painter. A representational one. This makes me until recently a dinosaur in the contemporary art world. Yet

practicing any discipline over a long period of time gives one insights. Some things emerge clearly; others become at least a little more clear. Some things I had assumed or had been told were true or relevant, I discovered with experience were not. What follows are principles that are essential to authentic expression, at least for me. They are not necessarily completely distinct. I've separated them for the telling but obviously there are overlaps and some points could appear under several principles. Some are particularly relevant to representational painting. But many, I feel, are common to all creative activity.

■

PRINCIPLE ONE
Searching for Beauty

Though we travel the world over to find the beautiful,
we must carry it with us or we find it not.—Emerson

•

By God, when you see your beauty
you'll be the idol of yourself.—Rumi

•

I told Beauty, take me in your arms of silence.—Aragon

•

Beneath our loquacious chatter, there is a silent language
of our whole being which yearns for art and the beauty
from which art comes.—Rollo May, MY QUEST FOR BEAUTY

I read some years ago that scientists had not come up with an agreed-upon definition of stress, one that from a scientific standpoint met with common approval. Yet any layman can readily define stress. The experience is clear, even for the scientists who can't formulate a definition of the word. Stress may differ from person to person in terms of cause, reaction and so on. But it is clear when we are having a stressful experience.

I find the intellectual wrangling over the definition of beauty to be similar. Over the years, I've made a study of beauty. I've read arguably the three most important writers on aesthetics—Plato, Kant and Hegel. They are not "an easy

read." Rather than addressing our simple, direct response to beauty, they write "about" beauty, in a broad philosophical context. Robert Adams writes, "Philosophy can forsake too easily the details of experience." Either we have the experience of beauty or we don't. It's like someone writing about self-realization. Either they've had the experience or they haven't.

This past month as it happens I've read two books that illustrate this point: Jed McKenna's *Spiritual Enlightenment*, and a memoir by Balthus, *Vanished Splendors*. Both men have truly experienced firsthand what they are writing about. They speak from an irrefutable depth and truth. Hard won. Resonant. Masterful. If the insight doesn't come from that level, it's mere intellectual speculation—perhaps intellectually engaging but in the end, experientially useless. Utterly useless. Interestingly, we have come to the point in the contemporary art world where beauty is suspect as an aim in art. It is not considered rigorous or tough minded enough to be taken seriously. It's almost a dirty word.

Yet if we look at the artifacts of all cultures, beauty has always attracted our attention. We know when we are in its presence. We're held. Different artworks will arrest different people, and as I point out in Principle Six, some art will arrest greater numbers of people for longer periods of time. These

are the works that are perhaps worthy of being called *great art*. We have to recognize that some people today, observing the greatest works of art or the most awesome works of nature—the Grand Canyon for instance—give these works but a minute before they're ready for something else. Insatiable for change, they are immune to deep resonance.

Art and beauty are about that inner resonance. It isn't the subject matter that holds us. Some inexplicable reaction stops us, and we find ourselves connected with something other than our self. Perhaps our "Self" might be a better term, to distinguish it from the self that is caught up in thoughts, worries and distractions. I like Ken Wilber's definition, that beauty "suspends the desire to be elsewhere."[1] In the face of great art, we experience transcendence; we are fully in the moment.

Because of this, if we're going to discuss deeper purpose in creative expression, we have to discuss beauty. As the art historian Kenneth Clark pointed out, the idea of the beautiful is the longest standing theory of aesthetics around. And for a reason. We can't help but come back to beauty. Like a perennial philosophy of spirit, it feeds us. In his book *My Quest for Beauty*, Rollo May writes:

> We realize now that our common human
> language is not Esperanto or computers or some-

thing having to do with vocal cords and speech. It is, rather, our sense of proportion, our balance, harmony and other aspects of simple and fundamental form. Our universal language, in other words, is beauty.[2]

By beauty, I don't for a minute mean pretty or sweet. Donatello, the Renaissance sculptor, had his sculpture of Mary Magdalene paraded around the streets of Florence when it was finished. The emaciated Mary is not a pretty sight, but it is an example of uncompromising work that was deep and accessible. If you think of Goya's painting, *The Third of May, 1808*, you see an extraordinarily powerful, beautiful painting that is also horrifying. This figure bathed in divine light, arms outstretched like Christ on the cross, before the dark anonymous line of the firing squad. That's a beautiful painting. It's not pretty. But it is beautiful. It is moving.

Philosophically the debate goes on about beauty and the sublime. Simplistically we could say one deals with pleasure, the other, awe. Goya's painting is probably an example of the sublime, as is the Grand Canyon. I don't think the distinction concerns us much in the making of art. You make art based on your nature. What you end up with may be one or the other. The more you think about it in advance the more likely you'll end up with neither.

One thing is certain. It is difficult to produce beautiful things, particularly to do so consistently. I know. I make paintings. Some have an indefinable quality that attracts people, and I could sell those images a dozen times over. People feel it. Yet it is far from something I can produce on demand. It is a constant challenge.

I mention this because much contemporary art simply doesn't attempt that path, the path of beauty. For artists to say beauty doesn't concern them because they have more important and deeper concerns—social or environmental issues for example—is fine. But I say: Don't knock beauty and don't call it meaningless or irrelevant or superficial without consistently trying to produce beauty and discovering how difficult it is.

If the current art market will tolerate work that ignores such basic tenets of historic art making, that is understandable, given the context of the times. But I feel it's similar to the hype that went along with the "new economy," the dot-com Internet world. The old ways of looking at stock price earnings and profits were not considered important any longer. A new economic model was in place. Yet the dot-com bubble burst and now everyone finds the old model of establishing a stock's value still relevant and demanding the same discipline as always. The heady trends of the "new

economy" have been found painfully vacuous.

Artwork that is destined to last is probably going to have to address beauty. A recent *Los Angeles Times* article on the art critic David Hickey stated, "he dared to discuss artworks as objects of 'beauty'—and what a marvelous ruckus that word prompted. To the reigning art establishment, the notion of 'beauty' is politically incorrect, outmoded, even dangerous."[3]

As an artist, placing yourself outside beauty's purview is now safe. This is a place, ironically enough, comfortably inside the status quo. But a look at beauty and its creation is very relevant to a discussion of divine or deeper purpose in expression.

Heidegger defines metaphysics as a search for "that upon which everything rests—a search for a reliable foundation." We would be in good shape if we had a reliable definition of aesthetics on which we could build such a foundation of meaningful art making. However, we do not. "Beauty is a topic of great philosophical interest and one that is relatively unexplored. Few would deny its importance, and yet the mere suggestion that it be defined drives intelligent people to witless babble."[4] But shouldn't we at least look and see whether there are some core ideas that would be fruitful? We're searching for ideas we can use, practically, in our art

and life, not a seamless philosophical argument.

The Greeks certainly were not afraid to address beauty. They obsessed over it. They defined two kinds of beauty. The first was a condition in which all the parts added up to one harmonious whole. No part could be added or removed without altering and perhaps destroying that harmony. The second kind of beauty, favored by Plato, was that in which the work allowed the Ideal Form of life to shine through.

In both definitions, the Greek word for beauty, *kalon*, was the same word used for goodness. The German language makes a similar connection. Gerhard Richter, the German contemporary painter, said that in German the idea that a painting is good implies that it is beautiful. The German word for good, *gut*, has almost a moral quality. "The aesthetic and the moral blend," wrote James Hillman in his essay, *The Practise of Beauty*, "as in our everyday language of craft where *straight, true, right, sound* imply both the good and the beautiful."[5]

> Human beings have an intuitive capacity and knowledge (what the romantic poets called *sensibility*) that somewhere at the centre of life is something ineffably and unalterably right and good, and that this "rightness" can be discovered through artistic and spiritual explorations that

have been honored by all the great perennial religious traditions.[6]

This is fundamental to authenticity in a spiritual sense. When we create beauty we somehow add to the light of society. Beauty is uplifting. It penetrates the density of what surrounds us and enlivens our world. We could never say that, like technology, art is progressive in a linear sense. That Modernist idea was simplistic and ran out of steam quickly because the premise was too small. It also lacked depth; it was devoid of richness. It was all didactics. The twentieth century seemed intent on finding an artistic expression that removed itself from everything toward which every civilized culture until that time had aspired.

Few in America would argue that their city's civic center, assuming they could find one, is more pleasing than Il Campo in Siena, or that the boxes and tubes that pass for public sculpture today are more pleasing than the many nineteenth-century statues we encounter on a stroll in Paris.

Economics and the International Style have ravaged our landscape. In older sections of American and European towns and cities, we find an architecture where design was not dictated by immediate economic factors. We see materials, proportions and decorative façades that please us as much today as they did the people who lived a hundred or four hundred

2 7

years ago. Beauty doesn't flourish in a culture that honors the bottom line above all. How can a significant architecture result when a corporation's quarterly report, reflecting the sensible use of resources to build a new factory—a metal rectangle one-thousand feet by four-hundred feet by twenty feet—must first and foremost satisfy shareholders? It's unthinkable that shareholders, instead of being concerned only with profit and performance, would be proud that their corporation built the most stunning corporate headquarters in fifty years in downtown Seattle or Minneapolis at the expense of their shares' appreciation. Corporations serve a specific function, but because of how all-pervasive they've become, with their short-term profit mentality, often aided by government complicity, we have an urban, rural and industrial environment that is not just ugly—it's killing us.

This point has a lot to do with the current art world, and with our own impatience when we make and view art. Beauty seems to need quiet and take patience, both to create it and to experience it.

If our minds are filled with a long and urgent "to-do" list, we are not likely to slow down long enough to appreciate anything but the next line we can draw through our never-ending list. Yet every now and again something in nature or art stops us. It arrests our constant external activity and

search. We can be stopped by the way the light filters through the trees in our backyard or hits a bowl of fruit on our kitchen table. And we are silenced, even if momentarily. We can be stopped by cave paintings as easily as by a thirteenth-century tapestry or a seventeenth-century ceramic bowl from Korea or a fifteenth-century Italian painting. We may be impressed by the craft of the artist, but almost always what moves us most deeply is the beauty that is expressed through the craft.

In the face of beauty, we are silenced, because beauty expresses silence. In lavishing attention on the object of the artwork, the consciousness of the artist can touch something divine, some transcendental quality, and that transcendent element now resides in the artwork. How do we know it? We feel it. We experience it. Our heart responds to that sublime quality the artist infused into the work.

A work of art is like a visual form of prayer. The depth of the artist's attention, the prayer, is what we respond to. We can be moved more deeply by a ten-inch by ten-inch Corot landscape or a still life by Chardin than by a ten-foot Ascension altarpiece. Our response comes from the power of the prayer that contributed to the making of the piece. The artwork lives. If we are left unmoved by a painting of the Virgin, it is likely because the artist was unmoved in the act of painting her. The subject matter is mostly irrelevant;

it is important only as a vehicle for the artist's attention. Authenticity results from the depth of the artist's feelings. And this is the key to how much silence, consciousness or attention the art reflects.

We may respond to a work of art in another way. The subject matter of a painting or the lyrics of a love song may move us sentimentally, but we sense deep down something superficial that we may even come to resent. Watching a predictable Hollywood romantic comedy, for example, I often experience a real annoyance at the sentimental romantic ending. The strings are playing and the guy gets the girl—which you could see was going to happen from the beginning. I feel manipulated, not moved. It is the same with Thomas Kinkade's paintings, although with a sentimental painting I feel not so much manipulated as repelled. Kinkade's response to the critics who say his art is irrelevant is to point out that ten million people have bought it and therefore it is profoundly relevant. This is an interesting point, but it has nothing to do with whether he is producing art or not. Ten million people have bought teddy bears—but we don't mistake teddy bears for art.

Subject matter functions as an armature through which you as an artist engage your intensity of feeling. It is the quality of your attention that influences how you see and how

deeply you feel. Different artists have affinities for different subject matter as a way into expressing themselves deeply. And that depth is the quality we, the viewers, respond to. It is what we continue to respond to over the centuries in great works of art. The fact that things last, that we continue to admire them, is in the end a good indicator of their quality, of their silence. Art museums therefore have little nodes of silence nestling in their galleries. They are filled with, to use André Malraux's expression, "the voices of silence."

History edits out the noise. Every age has produced paintings, literature, and music that are now ignored or completely forgotten. We've edited them out. On the other hand, we keep returning to those works that have silence. We respond on three levels to the silence and beauty. First, the context—the time and place in which the art was created and the community in which it was created. Second, the poetic view of the world to which the artist responded. Third, and finally, the plastic quality of the object itself.

There is always work that is ahead of its time and receives little acknowledgement in its own day. For instance, an artist may follow a line of discovery that is outside a rigid stricture of style or common understanding. Usually, even if the artist is ahead of public taste, there are a few admirers who recognize what the artist is doing. If his or her work has truth,

eventually the public will catch up. Even Impressionism, that most bucolic of art forms, and currently the public's darling, was reviled in its day.

Impressionism was an interesting phenomenon. Before the French Revolution, the aristocracy defined taste and style, which was felt to be in good hands. Artists created for a discerning clientele. In the decades after the revolution the middle classes became much more powerful and usurped what was left of the role of the aristocracy in defining taste and style. Those artists who pandered to this new, powerful and, as yet, largely uncultured class with sentimental Academic painting did very well. The middle classes loved the paintings that rehashed mythology and presented tidy virtues. Bouguereau for example was, at the end of the nineteenth century, the president of the French Academy and the highest paid artist in France. But with the rise of Modernism in the twentieth century, he was largely forgotten. Interestingly, at the end of the century we started to see him again, popular on posters and calendars.

But a whole sector of the art community simply couldn't manufacture work for that audience. It galled them. Two things happened as a result. First, they began making art for the first time without a clear-cut buying audience. A small, critically appreciative audience, well educated and progres-

sive, but usually with little money to spend on art, took the place of the patron. These were patrons who could honor the artists, even if they couldn't pay them. And so the starving artist was born. Second, art began to "shock the burghers," those complacent, self-satisfied merchants who were felt to have usurped the role of patron without the necessary refinement of understanding and taste. Almost a century and a half later, and despite social structures that have changed dramatically, this attitude of shocking the burghers continues in much contemporary art. However, the shock value needs to be more and more dramatic, even abusive, to have any effect.

If we think of art as primarily communication, we have to ask, do we seek abusive conversations? Does such a conversation say more than one that is quiet and still forceful? Take someone who rants abusively in a social setting, at a party for example. We don't have any trouble understanding his point of view but we'll usually avoid that person. His arguments may be very intelligent but we choose not to interact with him. Yet somehow with art we are encouraged to give "difficult" work its due. Such work may not be abusive, just enigmatic perhaps. But just because the communication is difficult or obscure, doesn't make it deep. It's one thing to give expression to something you feel strongly about. It

is another thing to find a simple way to express what you have discovered so another person can appreciate it. If as an artist you cannot communicate your ideas, and the public therefore does not appreciate your work, it doesn't necessarily mean that the public is not rigorous enough in its desire to understand the art of our time. The work of art has to communicate something. It reminds me of a bumper sticker I saw: "Just because no one understands you, doesn't mean you're an artist." Much contemporary art is very self-absorbed. It may have been fascinating for the artist to create, but it doesn't have the necessary hook to engage the viewer. We're left outside a private loop, perplexed.

Frank Zappa, the musician, said that art is about framing a situation. This is a contemporary, Duchampian idea. "Recontextualizing" in art critic jargon. And it is interesting in light of what you can see in a modern museum. The premise is, if I frame it as art, then it is art. Which is fine, but inherent within the framing are the cultural and personal associations we have about art. Is it good art or bad art? Is it relevant or superficial? Does it move us or not? In other words it can be framed as art but we still won't give it the time of day unless it can arrest us with its transformative power.

Sartre said, "Beauty is reassuring." Reassuring? A contemporary artist may say, no! The artist's role is to stir things up.

But if you want to stir things up, watch the six o'clock news. That's their job, to manufacture fear and concern, to show war, terrorism, serial killers, corporate corruption and everything else that is dismal in human affairs. Reflecting that in art hardly calls for much depth or searching. It's staring you in the face. The evening news is conveying it far better and to a much, much larger audience than any artist could ever hope to reach or affect.

Another contemporary means of making art that seems empty to me includes using the technology of the media as the vehicle for art, in which the means of communication alone is considered relevant, even devoid of any content. In Marshall McLuhan's famous phrase, the medium is the message. I've seen so many videos that go on and on with strange digital quirky effects leading nowhere.

Also the manufacture of third- and fourth-generation Duchampian artifacts, enigmatic and distant, falls into a similar category of emptiness. Each wave of that stuff that rolls in has lost so much more power and relevance than the last. And there have been many waves of it throughout the twentieth century. So much contemporary art is the rehashing of Duchamp's *Fountain* of 1917 and Malevich's *White on White* of 1918.

So if we, personally, are trying to come to terms with our

own creative expression in a contemporary art world that appears somewhat adrift, what do we do? As Wendell Berry says, "The possibility of an entirely secular art and of works of art that are spiritless or ugly or useless is not a possibility that has been among us for very long."[7]

Life cannot be lived well without standards. Art, as a part of our life, would obviously seem to benefit from standards as well. Those standards were well established one hundred and fifty years ago. They were agreed upon. We then had a long period during which we dismantled them. It was no doubt necessary. But the lack of standards in our modern life, or rather our current standards derived almost solely from economics, is ravaging the environment, ecologies, agriculture and urban design. So too our current art is ravaged, showing us disease instead of health, superficiality instead of transcendence and ugliness instead of beauty.

I think new standards of meaningfulness in art are resurfacing. Which is where authenticity comes in. Standards that are transformative, that will last, will have to come from a deep, quiet harbor of spirit if they are to anchor us today.

Beauty comes from giving personal expression to deep currents within us. That perhaps even wrench us in their telling. I like David Whyte's definition of poetry as "the art of overhearing ourselves say things from which it is impossible

to retreat."[8] Or soothe us in their telling, like Matisse who said he wanted the response to his art to be like sitting in an old comfortable armchair.

How the expression of beauty emerges will be different for each of us. Yet we need to feel our way to this deep transformative level. This is the simplest and most difficult aspect of making art that matters. Simple because it couldn't be any closer to us. Difficult because of all the "stuff" we throw up in its way.

But this is what we've chosen for better or for worse. Your own authenticity and growth ultimately are what matters. A work's resonance and truth are what will endow it with beauty. And hence lasting relevance.

■

PRINCIPLE TWO
Communication

Artists have two responsibilities. The first is to express themselves. The second is to communicate. If artists don't communicate, they have either been unsuccessful in their attempt or they are being self-indulgent by not trying, unless one of those rare moments occurs when a magical poetic statement happens for oneself alone.—Audrey Flack, ART & SOUL

•

Painting should call out to the viewer…and the surprised viewer should go to it, as if entering a conversation.—Roger de Piles, COURS DE PEINTRE PAR PRINCIPLES, *1676*

Art is fundamentally communication. We feel something and we want to give expression to it. We may be intent on others seeing it, or not. We may find someone who responds. We may not.

Within the initial artistic response to something is a core idea or feeling, and most of our work comes from stripping away everything that is extraneous to it. To translate that vision means "to get across" the idea or feeling. How cleanly can that idea be isolated and honed; how much can be stripped away? Everything superfluous and tangential needs to be eliminated. Otherwise the idea may get buried and our intention deflected. And the viewer's attention will too. The problem is seldom that an idea is too simple. Power comes from something deeply

felt and simply stated. "Nothing astonishes men so much as common sense and plain dealing. All great actions have been simple, and all great pictures are."[1]

We are not mere receptacles of this expressive power. Things do not just pile up inside us waiting to be regurgitated. We are conduits of spirit, of the divine. The spiritual flows through us, endlessly. Emerson called it "gleams of light" that flash across the mind. They are seed ideas that need nurturing and developing. They seldom come fully formed. The doing clarifies them. That is what creativity is—the gleam that passes so quickly through our mind and the catching of it and forming it into something. Inspiration is 1 percent of it, and perspiration, 99 percent. Can we with the tools at hand give expression to that gleam so that it still shines when finished and expressed? In developing the big idea, the big picture, we face the problem of having to use a myriad of details or parts to express the whole. And we can get distracted, caught in the details, at the expense of the clarity of the original feeling.

We respond to urgent forces within ourselves all the time. If we ignore or belittle them we will be covered so thick with doubt and disbelief that we will have almost succeeded in silencing them forever. The more we follow our feeling and give expression to it, the more it will flow. If we don't give expression to it, the impulse, that ecstasy and revelation of spirit, becomes

dull and lethargic.

To get an idea of our relation to the creative impulses that flow through us, we can look at the way we respond to our own finished work. Personally, I have two responses. First, I'm done with the image in terms of my attachment to it. Whether the painting has succeeded or failed, I'm pretty much through with it.

But paradoxically, I also have an almost objective fascination with the marks and traces of my work when it is successful. I look at it and am surprised, enthralled; I don't know how I did it. It's as if I'm looking at someone else's work. I am more astonished by the result than anyone else might be. I know that I have been in the service of spirit, a channel for the divine.

How does it happen? I think the right hemisphere of the brain just takes over and arrives at solutions that my mind, in its more left hemispheric engagement, would not or could not think of.

One thing is clear: The artist does not look at art the way others do. They don't look at the finished product the same way as everyone else. They have different concerns. Any experienced gallery owner can tell when an artist enters their gallery and looks at representational paintings. The artist will go right up to a painting, standing within several inches of it, and then retreat to ten feet or so away, and then go back up to the paint-

ing and then move back again. Depending on how engaging the work is, they'll continue like that, because the artist is concerned with the whole and how the whole was created.

I was once asked by an art history professor to talk with his class about several paintings in a collection in Chicago. I spoke of one painting in particular. It showed a woman turned away from the viewer, sitting on a table edge that had a huge bouquet of chrysanthemums on it. Interestingly, the painting would have worked better as a composition if the head had been removed from the woman. The shapes of the flowers filled the space of the canvas far better that way. I asked the students to hold their hand in front of the picture so the head was eliminated, and they agreed that it was clearly a stronger design that way.

What astonished me when I had finished talking about this picture was that the art history professor asked the students to wonder about this woman and why the artist had her turn her head from us. What was the artist trying to tell us? What was the psychological significance of it? And I realized that the professor had no idea what an artist does in the process of making a picture. It was as if he was on the outside of a restaurant looking through a plate glass window and trying to experience the taste of food on a table inside. He simply didn't seem to "feel" the dynamics of the picture plane of the painting in front

of him. So his intellect had to start constructing other kinds of meaning for him.

The same problem occurs regarding the headsets that are handed out at museums. Whoever writes those scripts is unclear about what an artist is concerned with and becomes distracted by biographical details that are often completely irrelevant to what concerned the artist.

The comments of the art historian and art critic are, if well enough conceived, art forms in themselves. But they are works of fiction, critiques of the writer, not the artwork. The artwork contains its own critique if we resonate with it and are responsive to it. Few writers will ever help us enter the spirit, the vision of the original work. So the same problem exists in looking at art as in making art. We must enter it firsthand, with the courage of our own response regardless of the consequences. The art is the original text and holds its own account of what is relevant.

Historically, most art served a communicating function for someone or something other than the artist. An altar or church portal, for example. Nowadays, the communication of the artist is considered an end in itself.

Of interest is the response today to "art" that wasn't considered art by the person who created it. The concept of art didn't exist for a cave painter, an African fetish maker, a sculptor of

a Gothic cathedral. These people were engaged in activities closely connected to the experience of the divine, or of spirit, even though throughout most of the history of Western European art, art was clearly in the service of a social function. In seventeenth-century Europe, Gothic sculpture was considered inferior because it seemed primitive. During the twentieth century we aestheticized our vision to include all works of all periods as candidates for great art. We now judge two African fetishes for their "formal" qualities, one being "better" than the other. The tribe that commissioned it would have had far different concerns than aesthetic ones, such as whether it produced rain or not.

And the formal qualities we attribute to the fetish, for instance, would probably have been totally incidental and irrelevant. They are apparent today as much from the harmonizing patina of age as from the concerns of the craftsman who made it.

Art had a direct meaning in terms of the social function it served. The artwork was authentic to the need. Today, we lack the deep conscious connection to the social and religious functions that artifact used to fill. Art is no longer bound by those functions. Now it is seen as plastic, "new" or "hot," terms tied up with marketing. The bedrock institutions that inspired art historically are long gone. But the original social need for

it still exists, uninstitutionalized and real, deep within us. The lively current of life and vision that reside within all of us still need expression, not just for the one who makes it but also for society as a whole.

Artists hold many different ideas about their role in communicating. One school of thought emphasizes that since the artist is communicating a response to something, he or she should make that response intelligible. It should be adjusted if necessary to the audience. This idea is not so commercial and repugnant as it might at first seem, since most Renaissance painters ran "workshops" that were clearly market driven in the sense that the client was commissioning something very specific and if he didn't like the piece, the artist would be out of luck getting paid. Rubens, that great ambassador of aristocratic painting, marketed the engravings he commissioned of his large paintings to promote himself throughout Europe. Artists glorified the church or the status of the patron. If they didn't like that role, they ended up like Rembrandt, with patrons few and far between.

Another school of thought is that the artist should not alter anything for the market. The artist must stay absolutely true to his or her vision, regardless of the consequences in the marketplace. This idea, that the personal expression of the artist is paramount, is, as a culturally acceptable idea, a new one.

4 6

The idea that to remain fully focused on the personal, which in fact connects us to the universal, and therefore touches us all, is a wonderful idea. But unfortunately a lot of very personal work is really just that—very personal. It's like hanging up dirty underwear for consideration. Just because it is personal, because it is interesting to the artist, does not guarantee that it is universal or relevant. Deeply felt, authentic work does connect to something universal and hence touches a lot of people. But just being personal, just revealing ourselves, is not necessarily going to move anyone else. It's like watching some of those talk shows on TV where people go through the most personal and embarrassing dramas publicly. This is clearly personal stuff. And should probably be kept that way.

To see the difference between "personal stuff" and fashioning an authentic, deeply personal expression, we can think of one being ego driven, agitated and afraid, the other drawing from a source that feels like revelation. It is revealed.

Emerson, I think, clarified this idea in the comment I referred to earlier. He said a person should learn to detect and watch that "gleam of light" that flashes across his mind from within. The gleams of light are the seed ideas that need nurturing and developing. They feed us all the time, if we would only listen. Initially, they are perceptible in only the broadest outlines. We need to bring them out into the world.

The clarification, the forming, manifests these intuitions as art. We articulate the idea. And that articulation by artists and writers, architects and musicians, and so on, is all that remains of each past culture we now admire. Each person communicated that inner impulse in their own way, filtered through the time and culture in which they lived. And that is exactly what you do today, giving form to and communicating that same infinite creative source that all artists have drawn from in all art forms in all cultures.

■

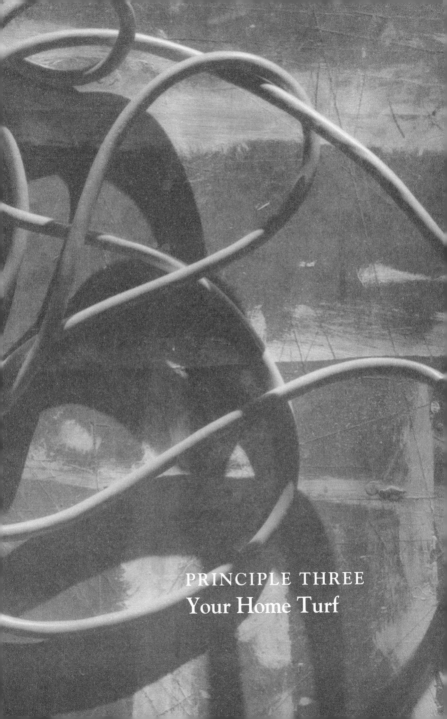

PRINCIPLE THREE
Your Home Turf

The landscape listens and we hear
it call our own name.—Emily Dickinson

R obert Frost said, "Locality gives art." He was referring to the writer's need to dredge up details that bring a place alive in the reader's mind: the smell of ripe apples in the autumn sun, the burnished surface of family silver carefully put away at the end of a meal or the clipped and hurried speech of a minister. The insightful observation is what conjures up the writer's imagined world for us. For a painter, those details might be the way the afternoon sun creates halos around the trees in the forest at the end of the fields, the lost edges of a sitter's hair against the background or moonlight in the mountains so bright you can read by it.

But art isn't just a question of details. It is details that are evoked in a particular place, what the painter John Hartman calls "his home landscape." Constable described it like this: "I should paint my own places best. Painting is but another word for feeling."

We slide into certain places. They speak to us. There is resonance. These are the places that we can mine for material. We can obsess here. We are at home.

From time to time we may meet a person with whom we feel an immediate rapport. We feel we've known them forever.

Places can create the same feeling for us. Or they remind us of other places, perhaps where we grew up.

I had that experience once in Tuscany. I was living there for a year, going to school. I would go out into the landscape every day, painting. Although the countryside, its cypresses and buildings, the olive trees and hill towns were stunning, I wasn't connecting particularly well with these surroundings, and the paintings expressed my failure to connect.

On the weekends I would go to different hill towns, Lucca, Siena, Arezzo and so on, and one weekend I went to Urbino. It was farther away than the others and en route I passed through the little town of Anghiari, whose only claim to artistic fame is that Leonardo da Vinci planned his fresco for the Pallazzo Vecchio competition with Michelangelo on *The Battle of Anghiari*. The fresco was never finished, like most of Leonardo's work.

But when I passed through this town and its surrounding valley I felt I had come home. It looked like southern Ontario where I had grown up. Certainly it had vineyards and mountains in the distance that Ontario didn't have. But the feeling was somehow very familiar. I went back to Florence, packed my bags and returned to Anghiari for a week. I rented a small hotel room and painted that warm, ripe autumn landscape. I did painting after painting and felt they were connected and resonated with something deep. In the evening I ate in a little

trattoria; the only other people there that week were a road crew. It was a deserted little town yet it promised and yielded much. I experienced a magical connection that showed in the work.

On the other hand, some years later I bought a Westphalia camper and spent almost three months driving all through New Mexico and Colorado, painting. This is great painting country. Everyone had said so. Each morning I would get up early and start exploring, looking for something to paint. Sometimes I would drive for two or three hours trying to locate a composition that moved me. And as the hours passed my internal critic would start to kick in: "You're just lazy, you really don't want to paint. Look at you—you avoid getting down to work, you're an excuse-ridden failure of an artist." I'm alone out there and by lunch I'm not in good shape. This was not my home landscape. It also was not kind treatment to myself. And if there is one thing we need to do, it is to treat ourselves with kindness in this whole creative process.

Your home turf is a state of mind. It may not be a place. Morandi's bottles are a case in point. Or Lucian Freud's figures. I don't know if Morandi could have stuffed some of those bottles and jugs in a box and painted anywhere, or whether his work was intimately tied to his studio and how it felt. When I look at the photographs of his studio, and particularly at the

table on which he set all those bottles and jars, I suspect that the sanctity of his studio was essential. For some artists the studio becomes a temple, a place invested with a sacred energy. You walk in and your thinking changes. I was looking at a book recently called *Artist at Work*. It featured the studios of several well-known American artists. In almost every case the space reminded me of a chapel or cathedral. The spaces were huge, soaring, and this was no accident. The physical, emotional and even spiritual elevation the space created contributed to the work.

This is the home turf of your creative space; it remains undisturbed by the rest of the day's energies. It stays open for your arrival. When you walk in you're filled with a heightened readiness to begin. A dining room table that must be cleared off for the evening meal requires more energy from you each time you begin. But a studio collects energy and focuses it, ready for your return. That personal space may be your garden, the view behind your house, or a desk in a bedroom that is reserved for creative work. It is your temple, the place where you focus your energies to express yourself. Your creative home base.

■

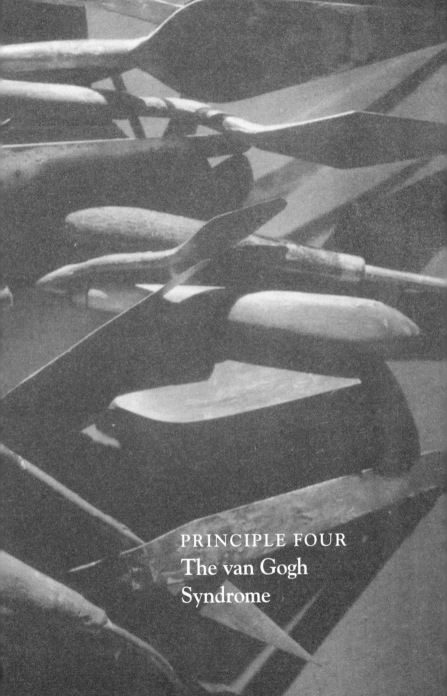

PRINCIPLE FOUR
The van Gogh
Syndrome

I don't think any one person has done more damage to our perception of the creative process than Vincent van Gogh. We could easily look at the myths and legends surrounding his life and conclude that to be creative, really creative, we need a far higher degree of madness, eccentricity and passion than we are able to muster. Perhaps we think that to be a *real* artist we need to endure great suffering and despair.

In the entire history of Western art, why do we latch on to this poor, crazy fellow, romanticize his suffering and equate it with creativity? There are hundreds of sane, stable artists who've lived normal lives in normal communities. Some may have been eccentric, but not crazy.

So let's get a couple of things straight about his life and its heroics. If you read what van Gogh actually said over the years, the *one* thing he does sound reasonably calm and rational about is his painting and its progress. It was everything else that was tragic.

Art historians claim he was driven insane because of a cruel society that failed to understand his genius. But, come on. His parents had wanted to commit him to a lunatic asylum *before* he started painting. When he did start to take a serious interest in painting—and remember, he only painted for eight years— several well-known artists were friendly and encouraging. But inevitably he would commit some outrageous act to break with

the person, which later he would regret. He desperately wanted a "fruitful life," which for him meant a wife and children. But no woman with any sense would have wanted anything to do with him. So the man was dreadfully lonely.

However, van Gogh did work. In fact, he burnt himself up. Literally. In order to paint the colors of the Provence landscape more vibrantly, he would venture into the midday sun and heat without a hat. He wanted to experience the colors scintillating in his brain. He wanted his brains to bake. He actually said that! Almost everything we think of as a "van Gogh," he painted in a fifteen-month stretch in Arles. Before that, his paintings were muddy and heavily influenced by some artist in Paris. Once he got to Provence, however, he came into his own. After that fifteen-month stretch in Arles he was in the asylum in St. Remy. In that restrained environment, his artistic frenzy may have been less, but he still painted over a hundred paintings that year.

Although the impression we have from the myths surrounding van Gogh is that no one understood him as an artist, this just isn't true. While in St. Remy—and remember he'd only just hit his stride a year and a half ago—he was invited to show ten paintings at the Salon des Indépendants in Paris. At the same time he was *invited* to show at the Art Society in Brussels, where he sold a painting to a well-known collector for

four hundred francs, a good price for a painting in those days. Furthermore, he was written up in a Dutch magazine about painters to watch in France. And the art critic Albert Aurier wrote an article on him, only him, for the *Mercure de France*. It was very positive. He wrote: "This robust, true artist, very much of his race, with the rough hands of a giant, the sensibility of a woman and the soul of a mystic, so original and so much apart from the pitiful art of the present-day. . . ."[1]

This is not a man reviled and ignored. Had he just kept painting he probably would have done well. But in addition to being understandably terrified of having further attacks of apparent insanity, which leveled him for weeks at a time, two things happened. First, the possibility of success really scared him. He said, "Success is about the worst thing that can happen."[2] He was beginning to get attention. Second, his brother Theo, who had supported him throughout his painting career (there would be no Vincent van Gogh if it hadn't been for Theo), had married and said he could no longer support Vincent. Three weeks later van Gogh shot himself. He was only thirty-eight years old.

This was one very impassioned, tragic and confused human being. His life makes a great dramatic story, but it is not useful for you or me as we attempt to create work that is truthful to ourselves.

In my experience, the artists I've met who I respect most in terms of focus and expression of vision are practical and generous people. The psychologist Csikszentmihalyi, who has focused his research on creativity, writes, "After years of intensive listening and reading, I have come to the conclusion that the stereotype of the tortured genius is to a large extent a myth created by the Romantic ideology and supported by evidence from isolated and—one hopes—atypical historical periods."[3]

We all know people who are eccentric in their personality or in the way they express themselves, and they may be considered "creative." But a solid, consistent body of work usually demands a character with those same qualities. He or she may be eccentric but is solid and consistent nonetheless. The artists and musicians who burn up in a tale of abuse have nothing to tell us about artistic practice, except perhaps what to avoid. It's somewhat like the difference between the ideal of romantic love burning up in the fire of passion and the love between two people who've been married for fifty years and share a deep intuitive rapport. One is mythical; the other is attainable and purposeful and yields deep, meaningful benefit.

■

PRINCIPLE FIVE
Your Craft and
Your Voice

Until one hundred and fifty years ago there was little debate about whether you were or were not an artist. To become an artist, you had to spend years drawing plaster casts and painting from life; your training would have brought you to a level of expertise immediately recognizable to an onlooker. You wouldn't have been able to fake it because the criterion of excellence was so stringent and difficult to attain.

In many artistic circles today, a lack of craft or skill is actually admired. In fact, this lack of skill is what is deemed to give the art its authentic contemporary look.

I'm certainly not suggesting we need to return to some form of widely accepted academic painting. But if you want to express yourself, learning your craft is a good start. I know art teachers who just want students to express themselves, as if the talent and ability are inborn and if the student just gets out of the way it will magically roll out on to the paper. But imagine having that attitude to a music lesson. If during your first class your violin teacher said, now just express yourself, you would think he or she was crazy. And your attempts to express yourself on the violin with no training would prove it. I cannot understand why people think painting is so much different, as though it happens naturally. Painting certainly isn't any easier to master than learning to play violin.

If we are diligent in learning our craft, our voice—what is uniquely ours—will come out in the telling. When I teach landscape painting workshops, and fifteen students are painting in some cases basically the same subject, fifteen very different and often remarkable visions of the same thing will be created. The skill level may vary dramatically and this will, of course, affect the success of the work. But it is obvious that fifteen people are looking at life, at the world, in remarkably different ways. Your creative expression is like your handwriting or personal calligraphy. Unique.

With practice we gain fluency in both the creative process and artistic technique. When people say they can feel within what they want to say but can't seem to express it, they are saying they lack technique. The Greek word for art is *techne*, which implies that the feeling or inspiration is not art. Only the realization of the inspiration in some manifest form is art. In other words, you must have the technique to give your inspiration life.

If we're serious about giving expression to our voice, we need to master whatever skills are necessary, whether it is the ability to draw or a better sense of composition. Until we deal with them, these problems will continue to stare us in the face graphically, boldly, in every painting we make.

We need to build a strong foundation for our voice, both

internally and externally. By externally, I mean our craft. As an example, I remember watching a TV show in which Yehudi Menuhin, the great violin player, gave a master class to a group of young violin players. All the students had won very impressive gold medals at international competitions; they were young but very accomplished musicians. Rather than going over subtle musical interpretation, Menuhin was instructing them, one by one, how to hold the violin. That's building a foundation.

Internally we build a foundation by going to the headwaters of our inspiration. We need to be clear about where our inspiration originates. I don't mean trying to figure out why we're attracted to this or that or what it means. That isn't necessarily relevant. Rather, we have to feel the truth, and trust in the current, the flow, and go with it. If we don't find and follow that current from our own source, then we will feel enamored of and distracted by every mark, effect and subject we happen upon in other artists' work. We will want to add that and try this. Obviously, we will be attracted to and influenced by different kinds of art and rightly so. But that attraction needs a foundation. Our painting will only be as deep as the depth we uncover in ourselves. We're communicating. We're translating ("bringing across") our vision.

If we're going to create art for the rest of our lives, we need to come to terms with what is uniquely our own. If we sidestep

ourselves and derive vocabulary from someone else, we may feel we're making great strides at the moment. But ultimately, we can't continue. We have to come back to address the matter of authenticity. Unless we do, it's like trying to use someone else's handwriting or personality. It can't remain satisfying.

We need to look at other art. We need to study it and react to it. We're not trying to reinvent artistic expression. Artists, as artists, are moved by art as much or more than they are moved by nature. Artists see subjects to paint based on how they have assimilated the art that has moved them in the past. There is of course a melting pot of influences. But have the influences been fired in the crucible of your own vision?

When we voyage to the headwaters we are becoming honest with ourselves. Twenty years ago, when America realized it was losing business because of a perceived lack of quality in its products, it was hopeless trying to improve quality as the product went out the door. It was already too late. A new way of thinking had to evolve way back up the pipeline of production and design in order to create a difference in the final product.

Making art that is authentic means eliminating those influences that have been picked up superficially and incorporating new ones that are more authentic. Work that sings to us may be a good indication of where to look, although our positive reaction may simply be due to the fact that the artist has found

6 7

something so true and real we mistake it for our own. It may have nothing to do with our own work. There's an artist in Canada named Betty Goodwin. She had been making different things, sewn vests primarily, as I remember it, for years. Not particularly memorable, perhaps, but she was dedicated to it. Then sometime when she was around sixty years old she started making work that was so raw, so penetrating, that everyone—artists, dealers, museums, writers—noticed. She did a lot of her drawings on mylar. And, within the year everywhere you turned there were drawings on mylar in all the galleries. She had definitely hit on something that rang true to a lot of people. But whether that meant mylar was the surface of choice for all of them, I don't know. She hit something real after a very long period of working. Many artists tried to appropriate what she had touched and used her methods to try and add depth to their own expression. "There's a difference between meaning that is embodied and meaning that is referenced."[1] In other words, putting a mythical figure into a painting does not give it the power of myth.

The source of truly authentic work is within. Each time we ignore it, we diminish it. Each time we reject it, it goes silent. We need time alone, and openness, to re-entertain our inner inspiration. It's still there, mixed in with everything else we call our daily life. In sifting through it all, and finding our own

creative source once more, we start to have a chance of expressing something real and moving.

Work that truly expresses something personal and true can sometimes get away with technical inadequacies. It rides on its power to move us, to communicate something to us. Art demands technique—but it amounts to little if we fail to bring to it spirit and vision. Spirit can illuminate a work with life even if there are technical flaws. But technique cannot breathe life into work that lacks vision. We've all seen paintings that are technically perfect and perfectly dead. On the other hand, we can think of the cave paintings at Lascaux. They have as much feeling as any high-tech film today. We've had advancements in technique, but few in depth of feeling.

Ben Shahn, the American painter, had an insight that forced him to reconsider his art from the inside out.

> [I] began to realize that however professional my work might appear, even however original it might be, it still did not contain the central person which, for good or ill, was myself. The whole stream of events and of thinking and changing thinking: the childhood influences that were still strong in me, my rigorous training as a lithographer with its emphasis upon craft, my several college years with the strong intention to become a

biologist: summers at Woods Hole, the probing
of the wonders of marine forms: all my views and
notions on life and politics, all this material and
much more which must constitute the substance
of whatever person I was, lay outside the scope of
my own painting.[2]

The question is, what are your themes or ideas? And can
they be given expression? You can't rush this. Those ideas may
be buried and surface slowly in pieces. Or they may burst out
fully formed—and scare the daylights out of you. You can't rush,
and you've got to listen carefully.

I remember reading about a research study concerning sev-
eral divinity students. Each was interested in doing missionary
work; they were interested in doing good deeds to help their
fellow man. The research study was organized so that each
student was given a sense of the importance and urgency of a
task they had to perform, which involved carrying a message
across campus. On the route that each one of them would have
to take was an alley, and in the alley a destitute and obviously
sick old man was sprawled. In their self-absorbed haste, each
of those divinity students literally jumped over the old man
as they raced across campus to deliver their message. Perhaps
under similar situations you and I would have done the same.
We may want to get started, to just paint. The point is that if

we rush, we tend to miss the big picture—what it is we *really* want to say in paint.

Getting started is essential. We feel engaged when the brush hits the canvas. And in consciously learning our craft we open the channel for our voice to flow. But "it does not matter how well something is done if it is not worth doing."[3] Expressing our voice, what we want to say, is what's worth doing. Technique allows that to occur. In every case the development of our work will be an intermeshing of mastering craft as we unfold clearer expression of voice. They advance together, like two sides of a coin.

■

PRINCIPLE SIX
Showing Up

Work, or I should say labor, and perseverance are the only guarantees of a work's authenticity.—Balthus

•

*How do we keep [our inspiration] alive? By using it,
by letting it out, by giving some time to it. But if we are women
we think it is more important to wipe noses and carry doilies
than to write or to play piano. And men spend their lives adding
and subtracting and dictating letters when they secretly long to
write sonnets and play violin and burst into tears at the sunset.*
—Brenda Ueland, IF YOU WANT TO WRITE

•

True art is in the doing.*—Jean Renoir*

Nothing determines the success of your creative life more than doing it. This is so obvious and fundamental, yet how much energy is wasted on speculation, worry and doubt without the relief of action. As Woody Allen said, "Success is 90 percent just showing up." I can't tell you the number of problems that are solved with this one simple principle, because when you start, it leads to something, anything. And when you have something tangible in front of you, then you can react to it and amend it. And that will lead to something else. In the book *In Search of Excellence* by Tom Peters and Robert Waterman,

Jr., which looked at companies in America that excelled at what they did, one of the guiding principles was, "Do it, mend it, fix it."

We can't get around this. I've looked at many books on creativity and expression and many of them create exercises of making masks and altars to your creativity—like getting in there at the sandbox level in order to get your feet wet. What bothers me about this is the appropriation of the trappings of aboriginal culture to lend a false depth and authenticity to the expression.

Perhaps this stuff works. I don't know. But ultimately there is some particular art form you wish to pursue—playing violin, sculpting wood, writing a novel, whatever. That's what calls you. That's the dream. You feel it. And you have to do it. Anything else just seems like more avoidance, a warm-up to nothing. Because in the end you're no closer to expressing what you have inside you than before.

So the question is, are you going to follow your dream or not? Do your art supplies stay in the closet with the running shoes and diet books or not?

The wonderful and terrifying truth is that expression of your authentic voice takes courage—courage to face the fear of failure, ridicule and incompetence.

Central to getting started is knowing you're being called.

Our spirit calls us to express ourselves, to say something. It is a voice that won't be shouted down, a desire to explore what sings to us quietly inside. We are being called. The call is divine. It is perhaps our conversation with God. As Julia Cameron puts it:

> Creativity is really a spiritual issue, point blank! Period! It takes courage. Another word for courage is faith—and scripturally we say "faith without works is dead". Creatively it is exactly the same thing, so the whole trick is to get people into action, to take creativity out of the realm of theory and into the realm of practice.[1]

As I suggested in the introduction, this book is mostly for people who are painting or writing already. It is for people who may be confronting limiting ideas about their expression but aren't paralyzed by fear.

Students of many levels of ability, experience and determination attend my workshops. Some are on a holiday and feel painting is a wonderful way to spend time in nature; their appreciation of nature is heightened. Others are keener, looking deeply at painting and at themselves. Some are there to learn. Some are there to express themselves and are not that attentive to learning. Everyone has the experience of being told to pack up and being shocked that six hours have

just passed since lunch. Everyone struggles with new ideas, technical problems, frustration and doubt. And everyone has moments of sublime satisfaction, openness and connection.

As students become more engaged with their process, they begin to worry, "Am I talented enough?" This is a natural enough question, because now they see vaguely where they want to go and wonder if they have the ability to get there. But the question is irrelevant. I think the best definition of talent I've ever heard is Whistler's: "The ability to do hard work in a consistently constructive direction over a long period of time." Nothing about natural gifts or genius. Just about practice—showing up.

You realize that in the doing, things line up. With practice, you just start in the morning and even though all kinds of unwanted thoughts come up, you continue and produce a result. You learn how to enter the work each morning whether you really feel like it or not.

At a certain point you realize this inner calling is real and won't go away. You may have buried it for years with work or family. But it resurfaces. It calls your attention. You may see a painting in a museum that opens you like an exquisite wound, that pushes you toward the realization that you could be doing that!

You realize you can't give up on this inner calling again.

You know this time you must respond. Then the question of whether you are able or not, good enough or not, becomes irrelevant. Then the relationship to your creative expression becomes similar to raising a child. Your responsibility is no longer a choice. It won't go away. If you want your creative expression to grow strong and free, you must nourish it. You must cherish it, though it may often drive you crazy. Your creative inner voice will mirror your weaknesses to help you grow and show you moments of connection and creativity you can only describe as divine. The question of whether you are creative or talented enough becomes as irrelevant as asking whether your child is intelligent enough to deserve your attention.

Raising a child involves situations that constantly test you. Routines and patterns are constantly being broken to make way for new ones. So it is with your creative work. Just as some line of work seems established, you're happy with it, the gallery's happy with it and people are buying it, something starts shifting inside and doubts creep in. Something else is calling for attention. Something else wants a say.

But in all this, once we've started, we have momentum. And momentum can carry us forward even when we're confused about where to go. It's starting from scratch that's most difficult. But with some momentum we've got some idea of

what to do.

Keeping a sketchbook-journal can give us a resource of possibilities. No matter how much or how little time we have for their development, writing down notes or ideas or images is crucial. Writing them down the moment they come to us is also crucial. For two reasons. First, if we delay, those ideas will disappear like our dreams in the morning. Two hours later, what seemed so clear and obvious is gone for good. Second, these ideas are our lifeline to our voice. When we give them attention, they grow stronger. By honoring what pops up, we say to ourselves that such things matter. If they don't matter enough to get them down in some form, even some kind of shorthand, no one else will ever be able to know if they matter to us. As Emerson wrote, "To believe your own thoughts, to believe that what is true for you in your private heart is true for all men—that is genius."[2]

Such inner conviction is what calls us to write or draw or paint. Your call is unique. No life is like yours. No one responds to life the way you do. Giving precise expression to that personal press of spirit in the stuff around you—that is "genius." The word comes from the Latin meaning "in the spirit of a place." We give voice to how our spirit blossoms in the face of something that moves us.

Emerson, as we have seen, mentions the "gleam of light"

7 9

that flashes across our mind from within. That gleam needs nourishing and developing. The more we pay attention to it, the more we find connection—a divine connection to the creativity of nature, to the nature of creativity, to the creativity of ourselves.

The screen that these ideas fall on, yours, is different from all others. Genius is recognizing its personal importance, trusting it and doing something with it. Because when we start, and start boldly, as Goethe says, "there's genius in it." Things start to happen. There is an expression, "with practice comes luck." Or, as Louis Pasteur said, "Chance favors the prepared mind."

There is no alternative to showing up.

■

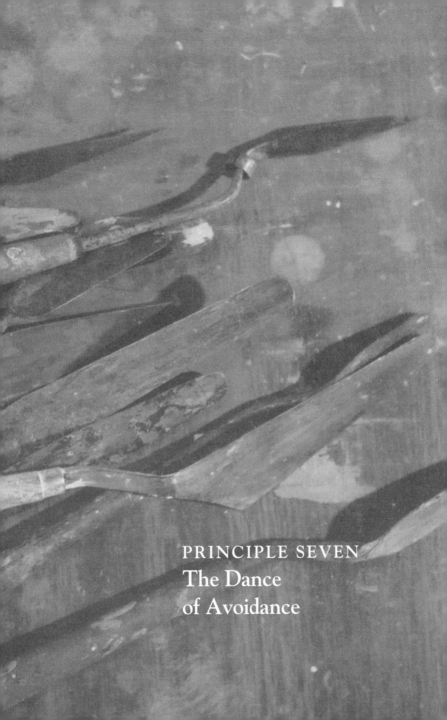

PRINCIPLE SEVEN
The Dance
of Avoidance

Whsen we approach our workspace, when we have finally carved out the time to start work, often we become our own worst enemy. Before we can actually get down to work, we have to sharpen a dozen pencils, call our sister in Seattle about plans for a summer vacation nine months from now, find an article that we were thinking about a few days ago, which just happens to be under a huge heap of papers. The distractions are endless. It's amazing the excuses we conjure up to stop ourselves from getting to work. In my own case, I've been painting for a long time. I knew I wanted to be a painter from the time I was ten. My father was a painter. The moment my brush hits the canvas I'm happy. I feel connected to myself. And yet I go through this dance of avoidance every morning when I go into the studio. It's inexplicable. I can't make it go away. But over the years I've learned to recognize it for what it is.

In recognizing the dance of avoidance for what it is, we learn to walk through it. And we learn to walk through it more and more quickly, without the emotional wrangling.

If at all possible, create a space permanently set aside for however you express yourself. Nothing will slow you down more thoroughly than having to set up and take down all your equipment every time you wish to work. If the feeling to express yourself is important, make it important enough to

create that space. That space gets invested with our creative energy over time. Like a temple or shrine we come to witness the expression of the divine in this sacred space.

When you enter that space you can and probably do entertain a different consciousness. This is not necessarily an exalted spiritual state; perhaps it is just a shifting to more right-brain activity. It certainly feels different. You need a few moments in your workspace to get comfortable, and that explains the need for some of the diversions. You need time to shift gears. But it's a crucial moment, because as we start to think in a more right-brain, spatial, unbounded way we can find a hundred "relevant" connections to follow and distractions that keep us from getting down to our work. There is obviously a fine line here. Creative work does need to entertain disparate and unconnected things. That's when new ideas emerge and connections are made. But if we follow them without some plan, some agenda of activity, we may find it's lunchtime and we're still flipping through magazines.

The desire to avoid starting is understandable. I mean, what are we starting? It's not as if we are entering a corporate office with a clearly defined job description that we can plug into each morning. There's momentum and safety there—a feeling that if everyone else is doing it we can't be too far

wrong. Despite what we're really feeling inside, we are lulled by the safety in numbers. But even in the corporate setting, reports have it that more time is wasted at water fountains than most CEOs would care to acknowledge. But that's a different dance of avoidance.

I was glancing through a book the other day about a new kind of business personality—the mystic—who is ordered, precise, intuitive. I got the impression this person would be at the office at eight o'clock having already worked out, meditated, eaten a bowl of sprouts, and taken public transport. It seemed too neat to me, and also phony. All I know about going into the studio is that it's messy—I mean the process, not the actual space. Keeping a clean, orderly workspace is a good tool for productivity, although if you've ever seen photographs of the inside of Francis Bacon's studio you'll realize this is only a personal preference. But I will say in defense of that idea that I wouldn't want to visit the inside of Francis Bacon's head. At least not for long.

The reason going into the studio is psychologically messy is obvious. The rules surrounding what we want to do, if we can even discern any, are not handed out by the human resources director when we arrive. If we are growing authentically in our expression, following our feelings and our instincts, whether we are feeling pulled in a new direction

or feeling stagnant in our present one, we are always hovering on the boundary of infinite choices. Of course, if we've been focusing on portraits for the last ten years, it's unlikely that we'll be inclined to drop this tomorrow for some kind of earth sculpture. The options we'll be drawn to will probably be less earthshaking than that. But that doesn't mean they are any less pivotal and transformative, because no matter how good we've become at what we do, when we are called to consider something new, this almost certainly takes us into unknown territory. We may think we lack the skills for the new endeavor. We're stretched beyond our capabilities. We may have had some wonderful successes, including exhibitions. We may have written some excellent articles. Yet at this moment we realize things have to change, that new vistas beckon. We know we have just walked off the end of a gangplank.

The corporate momentum I mentioned above is not there to rescue us. If you are having a bad day working at IBM, you may notice it but chances are IBM never will. If we're having a bad day in the studio, however, everything in our little creative domain just collapses. The stillness can be unnerving. It's as if everybody in the office has been shuffled over into R and D, which for us can't mean rehash and duplicate. It's often very discouraging casting about again for a new means

of giving expression to something that has popped into our head and won't go away. We know we can't settle for the status quo.

In this situation, continuing with something fairly close to home will probably help. Deciding to take up the flügelhorn or learn Sufi mystic dancing may be avoiding the hard work of digging deeper into yourself. It is rare that a person goes through such a radical transformation that something of what they were doing isn't the seed for whatever is next. Our artistic growth is an evolution just as our personal growth is.

Of course there are times you just need to refill or take a break. I find this usually happens after bouts of intense activity and expression—after getting a group of paintings ready for a show, for example. Being quiet and rethinking can be extremely productive. Yet our work ethic pulls us back toward work, busy work in the interests of keeping our inner critic at bay. Creating a block of time for only creative work—a retreat, say—can give you insight into your creative process. The time may or may not be productive in terms of new work but it will give you a chance to perceive how your mind functions, what it demands and avoids, what it relishes and rejoices in. Look honestly and you'll learn about yourself and your own creative processes.

I'm on a retreat now, as I write. Which is why I thought to

mention it. I've rented a small apartment in a tiny village in the south of France to paint; I also hope to finish the rough draft of this book. No TV, no newspapers, no cell phone (no phone, in fact), no Internet. There's so little demand on my attention that I become very aware of what my mind wants to do if it's just left to itself—how long I'm interested in reading, how long I can remain engaged writing, how I feel if it's raining and I can't go out to paint, how I feel when the weather is perfect and I can. Left to myself on retreat, I show myself to myself. I learn and accept and enjoy things about myself that are not so obvious when I'm home with a long "to-do" list in front of me. A retreat doesn't necessarily involve a marathon of activity. It's better to find your own pace and enjoy yourself. If you discover a sulking child, a relentless boss or a caustic critic hanging around your neck, get to know them. This is when they reveal themselves most dramatically. If you can't put these characters to rest yet, at least get familiar with their harangue. You must learn to see through them and realize they cannot serve you. You can discredit and defuse them, and then maybe you can be at peace.

Try a retreat, if you can, for ten days. Alone. See what you relish and what you avoid. This is not a holiday for you to catch up on your reading. You take your work and see what happens when you're left alone with it. If you do

avoid starting, it won't hurt to look at why. I don't mean long, drawn-out analysis, which can just be another expression of avoidance and may lead to recriminations and anger with yourself, which is definitely not the point. Deal with it quietly and kindly. Maybe you really don't want to do this after all. That is good to know and completely OK. But if you do feel drawn to push something out into the world and yet you don't or won't, somehow you're going to have to find out why. That's where the retreat can be really useful. On the other hand, you may just flow creatively for the whole retreat and your only regret is you haven't another ten days available to continue.

Even if we can't possibly take time off for a retreat, sometimes if a problematic pattern is apparent, we can just sit with it. We can ask ourselves in silence what we are to learn here, how to proceed.

I'm talking about looking at problems because the way we respond to them probably reflects and affects other aspects of our life too. Authentic creative expression can be a tool for growth. It can show us how to move forward on many fronts. If used with attention and intention, it can, like many other forms of activity, help us become whole. Our avoidances and habits in our creative work are a microcosm of how we express ourselves in the world.

From a practical standpoint, several things are worth trying in order to get through the inevitable obstacles we throw up when we enter our studio. I like Audrey Flack's description of a studio: "However large or small, work in a beautiful place. A studio is a haven, a place to grow, to learn and explore, a place of light and joy."[1]

Action overcomes fear. When we start, when we take the first step, we reduce our doubt. Thinking too much without action will paralyze us.

Some mornings there are so many details of life to take care of I feel pressured. I start on my "to-do" list and before I know it, it's three o'clock and I'm just not ready to go into the studio to start work. I feel my inner drive has been depleted. Obviously, there are days when something legitimate, important has to get done immediately and I have to take care of it. Usually though, if I leave the errands until the afternoon they all get done—and so does the work. Somehow it all works out and I am able to use the most productive time of the day for creative work.

Books on sales and management often talk of the 80/20 rule: 80 percent of your income, benefit, customers, etc. comes from 20 percent of your time, salespeople, focus. The point is that if only 20 percent gives you all that benefit, you need to be clear what that 20 percent is and put more

time and energy into it. The same is true for artists. We must decide what is important and put our life energy into that. We have to leverage that 20 percent as much as possible. It is easy and fulfilling to check off mundane items on a list we made that morning. Life seems purposeful and on track, except that each of those tasks may have taken us away from the thing we know is ultimately more important to us.

If you know you work most creatively in the early morning or late at night, use that time for painting. Schedule time each day or certain days each week to be in the studio or whatever workspace you have set aside. If you know that other times of the day are less productive, that your energy is low, use that time for errands. It's a matter of being attentive to what works for you, trusting that inner rhythm and using it to your advantage.

I think it was Annie Dillard who said that she, or writers she knows, stops mid-sentence at the end of the day. This makes sense to me. I do the same thing with painting. If I'm working on a passage toward the end of the day and it's going well and I can tell exactly what I have to do to finish the idea, I'll leave the painting right there until tomorrow. When I come in the next morning there is no hunting, no guesswork. I know exactly where to enter the painting, what to start on, and once I start, I'm in. Then that leads to the next piece and

that to the next and I'm rolling straight off.

Usually I allow a certain time on entering the studio before putting brush to canvas. I relish being in the space itself. It's like being in my own chapel. Your studio is a special place. Transformation takes place there. What takes practice is sliding into that frame of mind without sliding right by it into an unfocused right-brain soup, which may feel expanded and creative, but generally isn't productive. If we come into the studio to paint, reading about a painter isn't addressing the issue. Time is so short, the path to authenticity, to expressing what lies within, so vague and intangible, that if we don't overcome our dance of avoidance we may find we've simply run out of time.

■

PRINCIPLE EIGHT
Full-time or Part-time

W hen teaching workshops I encounter students, some of them very competent painters, who express their desire to work full-time as a painter. Because they paint they automatically feel this should be their aspiration. It is important to consider this carefully.

Building "the perfect studio" for example can freeze you. I've seen it happen. The creative fire was lit in the process of building the studio. But when it was finished the person was confronted with the real issue—what am I going to say in there, now that there is no excuse for not producing perfect creative expression in this perfect studio? Also, given the pressure of having to create enough work year in, year out to supply several galleries, as well as promoting yourself, would that suit you? Would it really make you happy? Would relying on the sales of your work to pay the bills create so much anxiety that it would undermine your creativity? Would the insecurity plague you? These are important questions because nothing can sabotage you more quickly than your own terror of producing on demand. And nothing will take the joy out of creative expression more quickly if you are not suited to this way of life. Some very good artists work part-time in the sense that their financial security is not dependent on sales. Some form of teaching is an obvious supplement. I don't mean full-time teaching at a high school, or even college,

but workshops in your studio or at a local community art school.

Of course, there is the conceit that having to teach suggests you aren't good enough to earn a living from painting. Historically, however, every major artist whose work we value today had apprentices and students.

I don't believe in the starving artist as a meaningful myth. I know lots of artists who do very well. Some of them are clearly market driven in their choice of subject and technique. Others have enormous integrity in how they carefully give expression to their own vision.

And whether you're full-time or part-time, showing your work and selling it is a touchstone to your ideas and expression.

Making a decision on this issue is a personal, inner choice. No one but you can possibly know how you will react to the demands of productivity—and when you're working full-time as a painter, productivity is the name of the game. There is nothing glorified or authentic in feeling frantic and miserable as you watch a deadline approach for a body of work you believe is not representing you well. The burnout from this sort of activity can take all the joy and spontaneity out of art making.

Some artists find it easy to create for a market. Others do

not. Edward Weston, for example, had a commission with a coffee company. The company wanted to use his exquisite photography of objects, and all he had to do was include a coffee can somewhere in the photograph. No amount of trying enabled Weston to incorporate that one constraint. He hated the commission and in the end couldn't do it. Rubens, on the other hand, painted fourteen extraordinary paintings, now in the Louvre, full of gods and angels and regal symbolism on the inconsequential life of Catherine de Medici. That doesn't necessarily mean that Rubens was the more creative of the two artists, although he probably was. He was simply able to work under very different degrees of commercial constraints than Weston.

The art historian Kenneth Clark, who created the *Civilization* series for the BBC, suggested you could destroy all the works of any artist except his or her four most important works and the artist's entire reputation would continue to stand on the strength of those four pieces.

Clark is saying that in any career there are a few moments of creative insight that give full expression to an artist's vision. The rest are at a lower level of inspiration and do not grip us in the same way. For example, we've all been to museums and seen Renoirs and Monets that are embarrassingly bad. If not for the economics of the art world, the

painting found turned to the wall in the artist's studio at his death would remain hidden from view.

This raises a vital question: How many paintings can we produce annually that will carry a richness and density of vision worthy of us? There may be a certain superficiality inherent in the idea of producing forty or fifty paintings for annual shows, year in, year out. Some artists seem able to do it. They just have a gift for creating those few poetically arranged shapes that people love. It's like someone who can write pop tune after pop tune. But there are not many who can do this consistently. And there are probably none who are not repeating some well-tested themes over and over. I have seen artists who are doing well and selling well extend themselves to two or more one-person shows in a year. By the second year already the work looks weaker; it's begun to wane. It seems there are only so many strong compositions an artist can come up with in a year. The exact number will be different for each artist. But I don't think a good painter can just roll out deeply felt, relevant work in unrestricted number.

So finding that optimum number—and it will change from year to year—and deciding whether you can produce such work on demand and full-time, and whether the earnings from that would support you financially, are fundamen-

99

tally important questions. It may be that working part-time at something else, while also ensuring that you get enough time to express yourself, may be a far wiser path than fulfilling a dream of becoming a full-time artist only to find that it makes you miserable. On the other hand, you may be one of those artists who have enough paintings in them every year, year after year, to thrive joyfully.

■

PRINCIPLE NINE
Follow Something
Along

*Like to do your work as much as a dog likes to
gnaw a bone and go at it with equal interest and exclusion
of everything else.*—Robert Henri

•

*Grim truth informs us that the greater number of us
must make do with lesser ideas [than Cubism].
And great or much less, I was possessor of an idea
and maybe that is what really counts—to hold your very
own idea. The idea is like a ship on uncharted seas;
how far it can carry one must remain to be seen.
We can only hope that the voyage will be a long and
interesting one.*—Hiram Williams,
NOTES FOR A YOUNG PAINTER

I f we are to say something authentic, we need to stick
with an idea for a while. We need to gnaw at it, mine it,
obsess over it. I've met creative people who are painting,
yet also distracting themselves trying to learn Photoshop
and taking singing lessons. It's true that Bernini managed
to sculpt some of the most virtuosic marble sculptures ever
produced, while also finding time to design buildings and
monuments that changed the face of Rome, write and pro-
duce plays and compose the music for them as well. But that
was Bernini. Most of us would do well, if we are interested

and serious about an art form, to settle into that one thing and follow it along. And then find a few core ideas to express through that art form.

We don't actually need a lot of ideas. Look at Morandi for example. Or Diebenkorn's *Ocean Park* series, or Wyeth at Kuerner's. Or Bonnard and the hundreds of paintings he did of the inside of his little house in Le Cannet. Or Cézanne and Mont Saint-Victoire. Or Monet and his garden. Or Vermeer and the light from the window on the left in his studio falling on one or two domestic figures and their props. The list goes on and on. You can get a lot of mileage out of an idea that is deeply your own. You can mine it like a vein of gold. You can rework it. Working ideas along or in series also means we're not starting from scratch each morning, wondering what we'll be doing next. The game plan is in place. The current piece fits into the whole.

Eventually the inspiration may run its course. But when you do find something that holds you, that you can obsess over, hold your attention there. When Alexander the Great arrived by boat with his troops to conquer the Persians, he had his generals burn the boats. The soldiers woke to the sound of the burning boats, which gave the clear message there was no going back. In the same way, we can abandon secondary ideas that aren't calling so loudly. Get your energy

flowing where your interest is most intense.

We need to keep our wits about us for this. We are responding all the time to our own path of discovery. Yet at the same time we usually find we are questioning and even discounting it. Making art demands attention so we don't pull ourselves off track. "Following our path is in effect a kind of going off the path, through open country. There is a certain early stage when we are left to camp out in the wilderness, alone, with few supporting voices."[1]

As you learn to follow ideas along, to process those ideas into music or paintings, you start to realize that the issue of whether you are talented enough or good enough is no longer relevant. Following your ideas and creating art is just what you do. It's like being in a marriage. A marriage has its ups and downs. It teaches us about ourselves; our spouse mirrors us, both our strengths and weaknesses. We don't entertain unrealistic romantic notions of marriage. A working marriage is something real and deep and tangible. And so is our relationship to our creative activity. It isn't a romantic existence, being an artist. At least for the artist. It's just what we've decided to do.

In this light we can find we not only question our current work but also perhaps question why we want to make art at all. We all have our ups and downs. I went through a period

like this some years ago wondering why I didn't feel more passion for the paintings I was then making. I spoke with a painter who had painted throughout his very long life, and he told me that passion builds with dedicated effort. We create it from within ourselves over time. It isn't something that strikes us from above, like a gift fully formed. Passion is self-generated. We earn it. Feeling an interest but not passion is no reason to doubt our potential in the career we choose. Like all of nature around us, we seek a constant unfolding. Hence the occupational hazard of most creative work—feeling chronically dissatisfied, except for the lift we get from time to time when we get a breakthrough or finish something well.

Students are often concerned about whether they're talented enough, but that is usually the least of anyone's worries. Finding a few good ideas that have a personal resonance, trusting them, working them, mining them—that's the trick. Then consistently taking steps in the direction that holds us, and trusting those steps, will build momentum. That momentum will build a career.

■

PRINCIPLE TEN
Wagon Train
and Scout

Some years ago, after many years of on-location landscape painting, I entered an MFA program, which I stayed in for only one semester. However, the experience prompted me to question my artistic roots, and I was soon doing some very experimental things. One thing led to another, and before I knew it I was mired in what felt like, when I walked into the studio each morning, an infinite number of options, each one as interesting and engaging as the next. Yet none of them necessarily stood out as distinctly my path or voice. After two and a half years of pushing myself to continue creating a great variety of work, I finally had to give up. It was during the heady days of the mid-'80s. I was meeting dealers and artists in New York, but I was holding off showing anything until I felt I had something significant to offer. Then came the crash of '87, which burst the art market bubble, and I had to get a job.

That experience taught me something about the importance of staying with your own artistic roots, your authenticity. I leapt off the gangplank, and drowned. Now I find a more useful metaphor in what my friend, the painter Dan McCaw, refers to as sending out your scout.

If you were traveling across the prairies in the mid-1800s, the wagon trains always sent scouts out ahead to find the best route. The wagon train was cumbersome; the scout

was nimble. They functioned together. It was an interplay. For artists, there's an interplay between where you are, your conventions, and where you might see yourself going, your innovation.

If your work is a reflection of yourself, how often do you go through such transformative life experiences that you are fundamentally changed? You may want such a life-changing experience, perhaps even desperately. But in reality such experiences are rare. And they need to be rare if we are to be rooted in life. We evolve incrementally. Creative expression, if it is authentic, will be the same. How can it be otherwise? In a life well tended, this is how it should be.

However, we do need to keep our expression growing, stretching out beyond ourselves. This is the scout. He ventures ahead, searching for pathways and obstacles before we, as whole creative entities, move in that direction. Consciously cultivating this relationship gives a confidence to our search. It gives authority to the directions we choose. Our growth is built up by an interplay between what we'd like to become and what we are. There's a connection from where we've been to where we're going. The interplay balances the Dionysian and Apollonian aspects of our nature. The one is wild and expressive, the other ordered and balanced. And in their conjunction is the alchemy of artistic vision. Craft

111

blends with expression, the heart with the mind, passion with reason.

The directions we need to find are seldom revealed by the bolts of lightning we sometimes hope for, bolts that would release us from the repetition of our own conventions. Sure, if we've been working on something, we can get a rush of insight after some period of gestation. This is like being in the mountains and suddenly coming over the pass and seeing the plains below stretching out for miles ahead. Our way seems clear, the direction obvious. Yet this comes from the trials of the mountain journey. In truth, our new vision is usually hard won and deserved. It comes from a specific attention on a specific path. And yet when we continue on the journey, we find again that even though that momentary overview may have clarified things for us, now we are back in the woods. The day-to-day struggle of fashioning our vision continues as before.

Daily our creative direction is rather a quiet affair. We arrive at indications of a direction we might take, like discovering a broken twig or two rocks left by a previous scout to suggest one path over another. And we need to listen and have confidence in our own intuition about which path we should take.

Certainly, having the conviction of our own opinions

helps. In this light I remember one of my teachers when I was nineteen at a very interesting art school in Toronto. He was the closest thing to a genius I had ever experienced. His attention, the range of his interests and his ability to make connections fascinated me. Many of his large paintings were extraordinary "historical" charts of inventions and historical facts and connections. And he had opinions. He was the first adult in the role of a teacher who expressed opinions to me that were outlandish, heretical, and liberating. All through high school I never heard opinions. I heard facts. Irrefutable facts. Dates, theorems, analyses of poems. All delivered, hermetically sealed, as gospel.

This teacher was different. He savaged van Gogh, not because of his lifestyle or emotional problems, but because of how badly he drew and how clumsily he painted. This is just one example, but it stood out in my mind. I realized from him that if you feel something yourself, then it's true. For you. Now. You can express your idea if you want and be shot down for a hundred and one reasons, but if you feel it, and until you decide to change that feeling, it's true for you. You may certainly be in a minority. You may read something that allows you, suggests to you or forces you to change that opinion. But I discovered from this teacher the importance of having opinions and not accepting popular conventions. I discov-

ered how this can help you perceive your own way. Such independence of thought and conviction allows the scout to do his job. You develop the sense to follow or at least look for the path that truly calls you. You don't just accept the wisdom of the accepted way, which you as a creative person don't want anyway. There is too much stuff in society and certainly in the art world that is sanctified garbage. And for various reasons of self-preservation or timidity nobody blurts out the truth. I like the art critic David Hickey's description of the art world. He writes that museum goers "derive sanctioned pleasure from an accredited source, and this makes them feel secure," and he also adds the comment that "art professionals, curators, museum directors and other bureaucratic support workers parade among us like little tin saints."[1]

The next time you look at art, really look at it, for yourself, quietly. Spend time in front of it. How do you really respond? Not to the name and its reputation, or lack of it, but to the work itself. And if it doesn't engage you now, forget it. Find the things that do engage you, dramatically. Things that make your pulse quicken, regardless of anyone else's opinion. And question every opinion on art, because probably that opinion is not motivated by a simple and innocent response to the work in question but is a complex response to professional, economic and cultural factors. For you, for your direc-

tion as an artist, there is in the end only one authority. You. Does the art work for you? Does it serve you? Does it move you? If not, it's so much kindling. You may find only three or four paintings in, say, the Metropolitan or the Louvre that on any given visit move you. There's nothing wrong with that. Museums are filled with a ton of second- and third-rate art. And not that many first-rate artworks will speak loud and clear to you on any particular day.

There's a quote of Ben Shahn's that describes what happens to an artist who puts too much stock in the opinions of others: "Under the charmed light of scholars, surrounded by abstract and learned discussion, his own vision and reality grow dim."[2]

Another thing I learned from that teacher in Toronto was how to look at other work as your research. As a scout it is vital to learn intelligent, conscious "looking" to find solutions to specific problems you are having in your own work. I did precisely that with two specific components of landscape painting. I looked at the color green and at foregrounds. Both those elements eluded me consistently. Visiting several museums to see how some really great painters had solved these issues was so much more instructive than going just to look at paintings. Sometimes letting a flow of work pass over us is a good general tonic. Ah, that rarefied air of culture!

1 1 5

But a tightly focused trip can yield concrete clues about how to proceed in your own work. You can look at other artists for ways to resolve the problems that appear in your work. You look not to appropriate their ideas and vision, but to find solutions to specific recurring technical or fundamental expressive problems you are having.

These are two roles of the scout. First, to venture out ahead of your own lumbering conventions, looking for new, exciting and passionate paths to follow. Second, to confer with the work of other artists as to how best to proceed. Many artists may have been where you need to go. Moving ahead this way gives your work integrity and keeps it growing.

■

PRINCIPLE ELEVEN
Working Method

I t's painful to contemplate the number of paintings that don't work, not just mine but also those in galleries and museums. Such failures may be adequately painted but they don't sing. The paintings have left the studio but they aren't happy. It's inevitable: As artists, there's work we create that simply doesn't come together. And for each of us there's only one solution to this problem. We just have to continue to make paintings and more paintings, and then for no particular reason all of a sudden we start to click and all the pieces that we've been working with, the direction we've been perceiving "as if through a glass darkly," is now open and clear, in all its glory. We paint and everything falls into place. That expression of being "in the zone" captures the experience perfectly. The momentum we've built up was essential to this new work. If we'd been passively waiting for inspiration, waiting for that flow to begin, it would have caught us too flat-footed to notice. The flow arrived out of the readiness that all our previous work created in us. Regardless of how sluggish the process may have seemed at the time, things were lining up in preparation, ideas were formulating.

The process of creating art offers a poor example of efficiency at work. Yet all the practice and preparation is precisely what makes us able to respond when for some reason suddenly all the elements seem to fall into place, everything lines up and we become as if conduits for the spirit. The rest of the time we

just have to work to keep the channel open until things realign. Then, inexplicably and in exhilaration, everything goes right.

So much of our output seems destined to be merely preparation. It's what makes the inevitable harsh judgment of our work when it's not going well so counterproductive, particularly when we compare our struggles in the studio to another artist's well-edited, curated gallery exhibition. When we judge our output against someone else's, we tend first to admire their mastery of their obsessions. We each have certain fascinations and because of the energy and attention we place on them, we excel in that area. So we may notice a painter's mastery of reflections or the way they handle the actual physical paint itself and think we can never paint like that. And perhaps we may not. Because that's their area; it holds them and they've wrestled with and perfected it. But it's not our area. Ironically, our own obsessions are so close to us we probably can't see them. We're blind to our own magic.

The length an artist will go to create a particular way of painting is also deceptive. We can think of Sargent who worked hard scraping and repainting pieces just to get that effortless look of virtuosity. We can't compare that with what we've just finished working on this morning. Just because someone's painting looks loose or facile doesn't mean it was done quickly or effortlessly.

I know a lot of students who are distracted by an artist's

color or painterliness. They want to paint like that. Yet what isn't always apparent is that, if the artist is any good, the color and bravado are embedded in a foundation. John Carlson, the landscape painter, said, "Confidence of execution comes from practice and long experience."

We can run into trouble comparing ourselves to other artists when our temperament is completely different from theirs, which means that we could never do what they do.

We can admire all manner of art and artists. We can learn from all kinds of paintings. But it is not productive to evaluate our work against someone else's work. What we're trying to compare doesn't. And it can be harshly discouraging to try.

Certainly it is foolish to judge what you accomplish in an afternoon painting session working with a model whose pose you didn't set up, vying for a decent view and decent lighting against the work of a painter who has been deeply moved by an idea, hired a model specifically to achieve that idea, and furthermore has personally set the stage and lighting to suit their specific purpose and then had a week of six-hour days to realize it. The same applies if you compare a two-hour on-location landscape with something done in the studio over several weeks that involves far more planning and adjusting than you could ever afford with a quick sketch.

I notice that students often start laying in colors and paint

just to cover the canvas, without being very attentive to what's going down—colors and values all over the map. They just want to get started and hope to refine it later. The problem is the surface of the picture plane is so alive and active that with every inattentive mark you make, you move further away from what you had intended to paint faster than you can possibly realize. It makes much more sense to try and get it right the first time as if it really mattered, moving intelligently right now toward your idea. And it really helps to have an idea. But just laying in paint as an unhelpful foundation completely confounds our ability to see what we've accomplished and where we need to go next. Every part is now reverberating with every other in a chaotic and confusing jumble, and trying to dig ourselves out of that mess may be too much for any painter.

This brings up two points. First, so much of what we do while we paint is a reflection of our character and shows us, for better or worse, and if we choose to see, our true nature. Not taking time to lay in a strong and meaningful foundation may be something that manifests in other areas. Art can be a remarkable feedback mechanism for our life.

Starting thoughtfully and with intention is not the same as trying to get it perfect. It just means trying to get it as right as you can as you go along. "Right" means being aligned to your idea. Aiming for perfection takes the life out of expression.

1 2 3

The second point concerns our idea or vision and the blank canvas. With each mark we are heading either toward that vision or away from it. And with each mark we also move toward more and more limits imposed by what we've already done. We set up a convention of expression and as we proceed, the painting has to conform to that convention. If we mix conventions, something looks wrong. An obvious example is a representational landscape with a building in the mid-ground that looks as if it belongs in the painting of a naive artist. It's too defined and detailed.

So in the beginning, we have more options than we do as we proceed. Unless we radically reconfigure what we originally had in mind, we get locked in. Which isn't a problem. Most of life is that way.

When we start a painting, we may feel elated, only to find that this quickly gives way to despair as reality starts to manifest. But vision always outstrips manufacture: "That pregnant disharmony out of which is born, world without end, the conflict between the scheme of things and the work of human hands."[1] If this is the case it makes sense to try and arrive at what we envision now, rather than allowing inattentive or even lazy meandering to derail us early in the process. "Making art provides uncomfortably accurate feedback about the gap that inevitably exists between what you intended to do, and what you did do."[2]

How can we cope with this inevitable slide from anticipation to elation then to despair as so often happens as the work progresses? As we start to hit bottom, experience will tell us whether we can salvage this particular work. We know that the emotionally discouraging slide is almost always going to occur; the question is, do we know when to quit or when to persevere?

Creativity studies by Csikszentmihalyi show that creative people tend to work keeping their options open as long as possible. They keep things fluid. If we fail to do this, we get locked in early in the process and may find we're just going through the motions. By committing too early to too much we may lose a sense of flow deep in the fabric of the piece.

I know this experience from painting on-location landscapes. I had grown up with a father who painted that way, and his friends painted that way. I had built up a response to the landscape that went from my initial feeling for a particular arrangement of elements in the landscape—the design or composition—to how to lay that down and paint it so that the initial response and my convention for realizing it were so tightly bound together that the end result was a given. The result was a well-conceived and well-executed representational landscape. And as long as I was satisfied with that result, I was fine. But when I questioned it and wanted to move out into new territory, my frustration was that the initial impulse and the conventions for expressing it were

so bound up together I kept arriving at the same result. This is a process I am still in the throes of resolving. It is a challenge, but the skills I developed during those years of painting, and the feeling that something new and more exciting is arriving, make me feel confident about what is unfolding. I'm forced to spend more time with the vision, sit with it, feel it so that I don't continue to express my established familiar conventions yet again. Then other possibilities may present themselves for consideration. It isn't currently as productive, and much of what I'm doing is in the studio from sketches and photographs rather than outdoors from life. This is a conscious move to separate myself from what I know how to do so well in order to move toward what I now desire but am unable to realize.

If there is one thing this experience has taught me, it is to stay with the initial impulse longer. Feel it and work with it, either in a sketchbook or in a notebook, but somehow simplify and extract essences. And have the courage to follow that for some time, pushing your initial idea in its conception, making it personal.

The reason this is so important is that most paintings are ruined in the first five to ten minutes—almost before they're even started. From then on it's a bitter struggle that was destined for failure from the beginning. This is because the foundation of the ideas, the essence, was not stripped bare and revealed.

126

Unfortunately, what happens is that by continuing without a strong foundation visually, you can paint in some of the parts beautifully. But if you haven't laid in the major masses with some sense of how they are interacting with one another, you may be painting in the parts in a manner that will never work as a whole. The key may be too light or dark, for example, or too intense in color or too broken in execution. The eye is distracted by parts of the painting you wanted to be totally subdued. But you like those parts. You've worked hard on them. Nevertheless, if you decide to alter or adjust your painting to fit the parts, you have little chance of building a whole that works. This reminds me of an expression—something my brother told me when he was doing an MBA. It's an idea used in business. When a team works on a project for some time and has invested considerable time and money and it isn't going well, everything spent up to that point—the sunk costs—even if it's hundreds of millions of dollars—should have absolutely no bearing on whether the project is scrapped or continued. It is continued only if going forward with it today seems like a good investment of resources.

At times we need to evaluate our paintings in progress the same way. Regardless of how much time and effort we've put into a piece (our sunk costs), that shouldn't influence our decision to stay with it or not. If we realize the painting is seriously flawed, we have to decide whether to continue or reconfigure it

drastically or abandon it and start again.

We must impose a foundation at the beginning. We must fashion order or meaning into our work. Art isn't about a random response. Life is full of random responses, but art is different. It is "that transformation of a given chaos into a desired and desirable order."[3] I have trouble with contemporary artworks that seem to reflect the randomness, noise and confusion of society. We've got enough of that. Where is the transformative power in such work? And if art can't be transformative, then what is it for? As if the evening news doesn't remind us enough of chaos and randomness! "Great art is judged by its capacity to take your breath away, take your self away, take time away, all at once."[4]

To hope to give this experience to another involves first experiencing it for ourselves. We must either consciously or intuitively take the wild exuberance of our experience and condense and shape it to reveal our vision. It is an act of will on the environment or most certainly on our canvas. What great painting, one that has stood the test of at least a hundred years of scrutiny, doesn't extract some vision from life and express it so we can perceive and be moved by it? That is precisely why we still look at good art. We still find it relevant and engaging today.

I find it unnerving to teach a student who discounts what he or she is currently doing as just an exercise. That's taking yourself

off the hook. If you're too tired to paint, go take a nap or quit for the day. But don't waste time. Give it your full attention. Now. "For the brain will do second-class work unless it is ordered or invited to do first-class work."[5]

If we're sloppy inside, it'll show in the work. If we're tired, it'll show. Lazy? The same. Hurried? Distracted? It will all show. Art is a mirror to the personality. If we're bored, our work will bore the viewer. If we love it, the viewer will know.

Art becomes a question of loving what you do. Not necessarily the finished result, although it is very gratifying to have satisfying results. But do you love the process? That's what pulls us forward, and also what pulls in the viewer.

I remember reading some years ago about a psychologist who had studied three thousand people at college and then followed them along for twenty years. He was studying who became wealthy and why. His conclusion: Of the thirty or so who had done well, the common factor was that when they worked at what they had chosen for a profession, time stood still. They might complain on the way to work but once they actually started work, time stood still. They loved the process itself.

This illustrates Joseph Campbell's command to "follow your bliss." He says that when you follow what brings you happiness and fills you with passion, you find you are on a track that was already there. What you are doing rings true. It has authenticity

for you.

Andrew Wyeth comments, "one's art goes only as far and as deep as one's love goes." It is only from within that love, obsession or focused attention that you will care enough to overcome all the personal, technical and conceptual problems that stand in the way of your ability to create something worthwhile.

I read Wyeth's statement to a class I was giving and one student took exception to it. She was seriously disturbed that I would use Wyeth as an example of a creatively authentic person. She was taking this phrase to mean giving expression to the whole being, the whole person. She was disturbed not by Wyeth's work, but by his personality. I don't know his personality. I've read a couple of biographies of him but certainly wouldn't say I know anything firsthand about the man. From my standpoint his work is extraordinarily authentic. You can feel it just looking at the work. You may not come away with a sense of someone who possesses a lot of personal warmth—but again, I do not know enough about him to judge.

But this student felt she did know. And she wanted to know how I could have a deep, meaningful discussion about gaining creative authenticity, which included becoming a whole person, and at the same time mention someone who, in her opinion, was narcissistic and unhealthy in his close personal relationships. This raises the question: What is the relationship between our

expression as artists and our personal life? Now for you and me, we can probably say that making art in no way separates us from our personal and social responsibilities. But does this apply to the genius who is driven by something that seems to transcend such responsibilities? We touched on this question in the discussion about the van Gogh syndrome. Bach would have answered yes. In fact, in his own case he dismissed the idea of genius, saying that anyone could have done what he did if they had worked as hard as he had. And he had seventeen children too. I don't know if he was a particularly good father, but for every story of an obsessed, imbalanced artist there are several in which genius is blended with common sense.

Certainly, the most compelling thing in both personal life and art is to be yourself. When we engage attentively and honestly, pay attention to the insights that come to us, see our denial and faulty thinking and engage in uncovering the obstacles and blocks to our expression, we understand that art is a wonderful medium for personal growth.

If we realize all this, we do ourselves justice when we claim to be an artist. Today, as we start working on whatever it is we're doing, let's claim our role as artists, being attentive to process as much as finished results.

PRINCIPLE TWELVE
Limits Yield Intensity

When people think of being creative, they have visions of freedom. Unrestrained freedom. The artist is free to do what he or she wants. Yet such a definition of being creative has little to do with reality. During the Renaissance, in painting, almost the only work that was created was commissioned. Usually, the nature of the commission was bound by the desire of the patron. An altarpiece had to fit in a particular setting. The shape and size were dictated by that setting; the figures of the patron's patron saint, the patron's portrait and various other favorite saints all had to be included. There were strict limits to what the painter could do. And musicians had to work under the same restrictions, composing for either the aristocracy or the church in very structured musical forms. Up until a hundred and fifty years ago, the great works of Western art were all created in an environment of extreme limits. Yet these limits did not restrict the art from soaring. An artist today who complains of having his freedom curtailed by a client has only to look at the heights that Michelangelo, Titian, Bach or Mozart managed to reach, even given those kind of restrictions.

Limits yield intensity. Beethoven said, speaking of Handel, that the measure of music is "producing great results with scant means."

I remember watching a dance performance in Toronto. The

dancer choreographed and performed several solo pieces and then was joined by her husband for the last piece. He could not walk and needed a wheelchair to move around. He was hooked up to a mike that amplified his breathing, which was soft but rhythmic, and this formed the music. The exquisite balance of a great dancer, her wonderful freedom and grace, partnered with the slow deliberate movement of her husband, created an extraordinarily moving spectacle. The courage and poetry of the performance were created out of the severe limits under which both performers worked.

Rumi says, "New powers of perception come because of necessity, so increase the necessity."

The powers of perception, when we talk of art, mean experiencing poetry, experiencing the mundane as divine. There's a wonderful German word, *verklärung*, which means the presence of the Absolute or higher level of expression contained in a more mundane level—the spiritual showing through the mundane.

The revelation of poetic experience gives us a glimpse behind the scenes of what we can refer to as a divine order. Obviously, this cannot be proven. But when we are halted by some arrangement of words, shapes or notes, we are connected to the silence underlying all creation. That silence exists as the bedrock of all our crazy experience, and when someone points it out or we see it directly we are arrested. We are in silence. We hear the

voices of silence.

All art that lasts, that continues to move us, has successfully given expression to a poetic response. They have responded to something "out there," in the world. Then the artist has focused on that element of the poetic, isolated it, honed it, reduced it, crafted it—so the ordinary and mundane are able to reveal the poetic.

If you look at the work of an artist over a lifetime there is always transformation. Some artists hit a lively place early and then seem to lose it later. Others find that place progressively throughout their lives; still others find it late. But regardless, they are all learning to isolate the poetic within themselves. That focus on the poetic in our own work increases our appreciation of the beauty around us, of our growth and our divine connection.

As an artist continues over the decades to translate their experience of the poetic into form, they learn to communicate more successfully, more deeply. They strip away all extraneous elements and artistic baggage. They say more with less.

The problem is seldom that what we truly, deeply experience is so simple it cannot be further simplified. It takes expertise to strip everything away to reveal the vision. That's what takes a lifetime.

But the poetic vision, the excitement, is the crucible. "A

state of excitement, and it is like a faucet: nothing comes unless you turn it on, and the more you turn it on, the more comes."[1]

Some things will naturally excite us more than others. This is precisely when the creation of authentic art begins, when we separate our inner-directed impulse from the outer-directed deluge of other people's work and opinion. "The artists are the ones who bare themselves to this experience of essence. . . . Their vocation is to communicate that experience to others. Not to communicate it is to surrender the vision to atrophy; the artist must paint, or write, or sculpt—else the vision withers away and he or she is less apt to have it again."[2]

The trick is to learn to juggle at least two things at once. We need to keep the initial impulse in its entirety before us, as we start engaging in the execution of the parts.

In my years of teaching I have found that students tend to start without a clear sense or understanding of what they are responding to. Or their sense will be extremely vague. When I look at their painting, usually a landscape on location, and ask them about what they responded to, they reply by describing the obvious elements in the scene in front of them. Often they are only lukewarm about what they are painting because the idea behind it is hardly formulated. I try to point out the gap between what they are actually painting and what pulled them to the scene in the first place. Then it becomes obvious to them, and

with some thumbnail sketches and suggestions the student can extract that essence out of the scene and begin again. And their newfound enthusiasm is then tangibly apparent.

In such a situation, to do other than start again is madness. If you're not excited by what you're painting and have not isolated what it was that excited you about the scene in the first place, your work is doomed. You need to condense or reduce the image, strip it so its essence glows.

Look to the great artists for confirmation of this. "Speaking of Corot," Malraux says, "they were not merely what are called 'good subjects', they are sources of exaltation—that creative thrill felt by the artist when he sets eyes on certain landscapes, certain figures, rich in intimations."[3]

In the long education of sifting through what they like and don't like, artists may find they interpret the world through the eyes of other artists. They see a Corot or a Hopper. At that moment, they know they've found a good subject because of the similarity of poetic attraction. They see through a set of limits or conventions that speak to them.

But as time goes on and you continue working, you'll find you'll no longer consider those subjects as relevant to your own work, even though they may still move you. The point is, they belong to someone else. Your own affinities now lie elsewhere. Or perhaps more importantly you have found your own affini-

ties. You respond now to your own internal song. Art is about other art as much as it is about nature. Everything we respond to has passed through our filter of artistic influences.

I think this is why students are so driven to find their personal style. Yet, like a newborn who, for parents, already possesses a distinct personality, beginning artists already have their own vision, in terms of the sense of place they respond to, the artists they love. It may take some time for the student to learn to express this vision and even more to trust it, just as it takes time for the child to more fully express their personality. But there is no such thing as a neutral style. There is pastiche—an early assembly that allows the person into the communion of the arts. It allows a person to get started.

The trick is to recognize what is going on and to begin to strip away everything that feels false. This is why art can be such a vehicle for personal and spiritual growth. Spiritual growth involves a rigorous stripping away of falseness and blindness.

History has shown that art can give expression to soaring heights of feeling. But those works of art are carefully crafted on a foundation of simplification, form and limitation. The limits yield the intensity.

■

PRINCIPLE THIRTEEN
Being Ready to Show

For some artists the road to exhibiting or presenting their work just seems to happen, effortlessly. It's destined. It's in the stars.

Other artists of perhaps greater ability and integrity may struggle their whole lives for a worthwhile presentation of their work. Individually there's only so much we can do about it.

We can focus our attention on what is truly meaningful and important and learn to express it as honestly as possible. Then we can look for an outlet to have it shown.

I meet artists who talk about the importance of marketing and getting their style right and so on. When I view the work the main thought I have is, don't worry about getting this stuff out into the world. Stay home and paint—a lot! Work through some stuff first. It is obvious the work just isn't ready for presentation. The problem is that they don't see that their work isn't ready. A mature sense of critical judgment of our own work is vitally important in developing work for galleries.

The desire to show the work is natural. It's like a musician practicing a piece and then playing to an audience. It completes the circle. As well, other people's response to our work can be enlightening. Much of the feedback will be a reflection of personal taste in subject matter or preferred

colors. However, some comments may resonate deeply.

In my experience, when the work is ready, an audience presents itself. Your attention on those paintings month after month creates a need in the world for their viewing. And the depth and integrity of the work will determine the venue for their viewing if you are open to it. Feeling driven to spend so many hours per week "marketing" your work, sending out slides to gallery after gallery is, in my opinion, a mistake. It's time largely wasted. I don't mean a gallery owner will come knocking on your door out of the blue when the work is ready. If life presents you with a lead or an introduction, you must follow it along because it may bear fruit, probably in a seren-dipitous way you could never have imagined. But the "cold calling" school of getting your work out there seems futile.

Spend your time in the studio. Work on your paintings. Make something of them. The outlet will come when the work is ready. Trust it.

When is it ready? Sometimes we are our own worst judge. If you know an artist who you respect and can show them your work, or pay them to critique it, by all means try that approach. But make sure you have taken enough workshops or classes to know that a teacher in a school setting no longer has much relevance for you. If you're still trying to figure out how to paint, it isn't fair to talk with an artist you respect to

get his or her feedback about whether you should be trying to show. There will be too many unresolved issues in your work for them to be able to say anything very helpful. You must learn to evaluate your own work and where you stand. That means looking at a lot of paintings—good paintings—and doing a lot of painting.

Sometimes, because of our nature, we may continue to undervalue our work when in fact it is ripe and ready to be shown. If one or two people you respect who are at least knowledgeable about painting say you're ready, the possibility is worth considering.

The kind of venue you choose for your first showing may not be important. A restaurant or a club is fine. The point is to see the work framed and on the wall outside your studio, where it's fair game for anyone to comment. Viewing what you've done in a public context provides you with a level of objectivity that is vital for your growth. You're now seeing it in the same context as other artwork you've seen over the years. Inevitably, you will view your work more clearly, for better or worse.

■

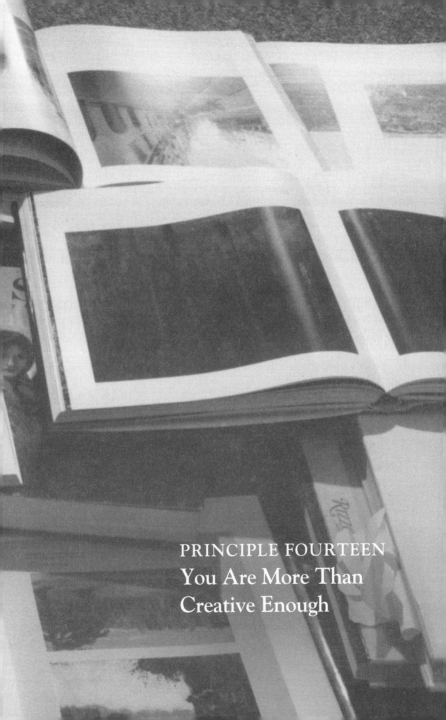

PRINCIPLE FOURTEEN
You Are More Than
Creative Enough

Always this energy smoulders inside
When it remains unlit
The body fills with dense smoke.—David Whyte

The question as to whether you are talented, i.e., skillful enough to produce good, authentic art, is irrelevant. Equally, so is the question of whether you are creative enough.

Creative enough! Do you realize that the number of combinations and connections your brain cells have to one another is more than the number of atoms in the universe? The problem isn't a lack of creativity; it is pumping madly through you all the time. It's well known we use only 5 or 10 percent of our mental potential, although what that really means isn't clear.

The problem is that we often take that creativity and subvert it, redirect it or distrust it. Eventually we are left feeling too small and inadequate to express anything. And we create that illusion in the face of this ocean of vibrant energy!

There was a film, a true story about a woman named Sybil. She had seven or eight distinct personalities, all vying for expression. One personality was talented at playing piano, another was socially charming and informed, another was childlike, others were totally shut down and incapable of functioning. It was a fascinating story, and the most fasci-

1 4 8

nating aspect was the tremendous if overworked creativity expressed by this soul who was simply trying to function.

The truth is, our souls are equally creative, though hopefully our creativity is expressed less dramatically. But we are handcuffing ourselves, telling ourselves we can't do this, we don't deserve to do that. Unfortunately what we believe expresses itself. We think perhaps we don't have enough creativity to be an artist. And yet we are in the midst of the most spectacular creative manifestation, giving our own unique and very personal expression to it, every moment of the day.

Look at the story of John Nash in the film *A Beautiful Mind*. He was imagining characters and interacting with them in a way that was obviously very real to him. He was creating it all internally, biochemically you could say. In our own way we create our own confusing and limiting life story. Not as extreme as the example of John Nash, perhaps, but nevertheless real and very debilitating.

The issue isn't that you lack creativity or that your creativity is blocked. Creativity is a gushing, fecund, unending torrent, which you could not block if you tried. The real issue is how to direct it meaningfully to your purpose. Just acknowledging how much of it there really is may help you get it going. Shortage of creativity is never the problem. If

you don't feel creative, that is an illusion of your own making and unfortunately we are masters of creating our perception of the world. The need to express ourselves is as basic as breathing. It's just that so much of that expression is not authentic or productive.

I remember as a teenager having two distinct groups of friends, one at school, one I hung out with on weekends. I functioned well except when I had to interact with both groups simultaneously. Then it became difficult; I was used to behaving very differently with each group. With one, I was the leader, very vocal and outspoken about my opinions. With the other, I desperately wanted to belong and thus adapted my behavior to fit in, which meant I wasn't really being myself.

That lack of authenticity is painful. It applies to all levels of life. If our voice as a painter is inauthentic, we're in trouble. In the end there is nothing as compelling as being oneself. This is why making art can be so exhilarating. If you want to uncover your truth, you have a daily technique to come to terms with your limitations and to overcome them. You have an opportunity to look at the limiting stories you have written in your head and heart and rewrite them with boldness and vision.

The quality of your attention influences how you see

things. And, what you put your attention on grows stronger in your life. Life, if you look around you, whether inside or in nature, is one bubbling mass of creativity. Recognize you have no shortage of it. If you focus your attention on what you now decide is fundamental, that quality will grow in your life. Not what your parents, teachers, friends or the media say or said. What you now put your attention on will grow in your life. If you want to paint and put your focus on painting you will unleash a torrent of energy and enthusiasm. I love the quote that is often attributed to Goethe and also to W.H. Murray. You've probably read it before but it wouldn't hurt to see it again:

> Until one is committed, there is hesitancy, the chance to pull back, always ineffectiveness. Concerning all acts of initiative and creation, there is one elementary truth the ignorance of which kills countless ideas and endless plans: That the moment one definitely commits oneself, then Providence moves too. All sorts of things occur to help one that would never otherwise have occurred. A whole stream of events issues from the decision, raising in one's favor all manner of unforeseen incidents and meetings and material assistance, which no man could have dreamed

would come his way. Whatever you can do or dream you can, begin it. Boldness has genius, power, and magic in it. Begin it now.

Look too at the process of your thinking as it tries to solve some problem. Over the course of a day, your creative imagination will come up with all manner of possibilities and directions. Most will be useless, some even idiotic. But we need to go through the process to eventually arrive at the one or two possibilities that may bear fruit.

It's interesting to compare what goes on in the mind privately, where no one can see it, with what we do when we paint or express ourselves creatively in some way. Now all of a sudden we become self-conscious and blocked. We have to realize that in our art, we need to go through the same process of search, with all the same kinds of dead ends and idiotic attempts that go on privately inside our mind throughout the day. This is just the way the creative process works. Avenues need to be explored, ideas tested. And like our thinking processes, most don't work. Some are clearly ridiculous.

But when we're thinking, no one, not even ourselves, "sees" the results. We go through the process internally. When we paint, it's out there in front of us, graphic, black and white, or perhaps in full color. If it isn't working, it will be oh so obvious. And while we don't take ownership of the

ramblings of our thought processes as we look for a solution, we most certainly do take ownership of the disaster we see on our easel.

Yet both processes are similar. I suspect there are only two ways to deal with the creative process. First, with courage. Just recognize the need for exploration and storm on. Second, with experience. With experience we move from product thinking to process thinking. We still want a good result, but with time we become more relaxed about how we are going to get there and what happens along the way.

Own your creativity. You are a creative being by nature, and your creativity is one with the unending creative energies that flow throughout the universe. The question is not whether you are creative "enough" but whether you will free yourself to express the creativity that is uniquely yours.

■

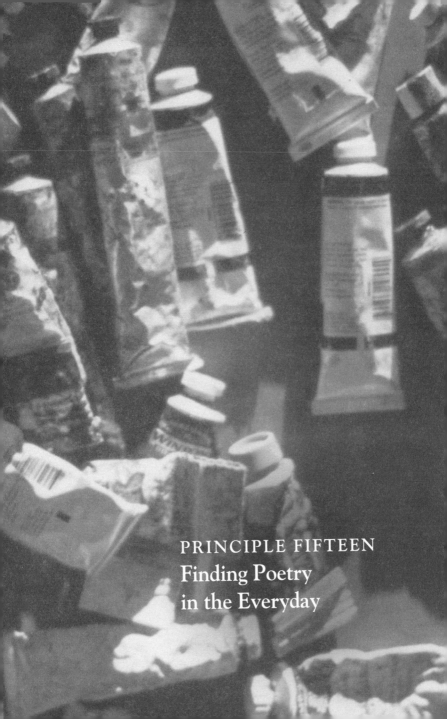

PRINCIPLE FIFTEEN

Finding Poetry
in the Everyday

What we need is more sense of the wonder of life,
and less of this business of making a picture.—Robert Henri

…Each venture
Is a new beginning…
…what there is to conquer
By strength and submission, has already been discovered
Once or twice, or several times, by men whom one cannot hope
To emulate—but there is no competition—
There is only the fight to recover what has been lost
And found and lost again and again….—T.S. Eliot

With each year that I teach workshops I become more aware of the necessity of emphasizing our intimate personal voice, of addressing the issue of our personal poetry. I've come to discover that the importance of this isn't obvious to a lot of painters.

Art is all about poetry, about vision, about seeing the ordinary as poetic, and then communicating that vision. That's the artist's job.

When you respond to something "out there," it must resonate with something "in here." Then you must focus on that object or metaphor, edit it, craft it, so the poetry resurfaces after having passed through the material and process of

your artistic fire. "There is no art without poetic aim," said Vuillard.

The essence of this whole artistic enterprise is to focus your attention on what caught your attention in the first place. Respond to what is yours. Your truth. It doesn't matter the subject matter, or the style. You must strip the thing back to the basics of what you feel about your response. What is the kernel here that you want to express? Get to the foundation and then build it back up. If you want to paint for the rest of your life, if you know it's your means of self-expression, then take the time and strip your vision back until you find your foundation.

If you take a more derivative route, copying or appropriating someone else's means of expression, you will sooner or later come up against the emptiness of such endeavors. You may need those outside influences for a time in order to develop an understanding of how to proceed. But at least be honest with yourself: You are appropriating things that are not yours.

The photographer Henri Cartier-Bresson said, "What counts is your eye, your sensitivity, and the strength of the shapes you make." Finding poetry is about condensing input, reducing it, firing it in the crucible of your attention. It means subordinating the subject to a composition of abstract shapes.

Paint compositions, not subjects. The picturesque detracts from meaning. Affectations of beauty and showiness will only distract from the power of the poetry.

The power of a painting rests on the power of its transcendence, the power of its painted surface and the abstract shapes used to convey the subject.

We cannot appropriate the power of past images by using them today. We can't assume that because they had a primal and elemental power when they were created that they will convey that power to a viewer now if we include them in our artwork. Such a work would become an artwork "about" a symbol. We aren't making art about someone else's symbol nor can we invest it with original power. That's why so much postmodernist art is so detached.

To find power we must delve into being, into Self. The depth of your painting will equal the depth of your contact with being.

If you read accounts of enlightened people, you will notice that because they are so open, with so few filters on their perception, everything for them is poetry. Everything is alive, asking for attention.

Attention to what? To the divine that hovers beneath the surface of all life. What we respond to in the great paintings of history is the depth of attention the artist had focused

on the project. We could even use the word prayer—not in a religious sense, although for some artists that might be accurate. But prayer in the sense of communion with the stuff of creation.

That experience of divine communion can leave us in awe: awe in its original sense. This is the sublime. It is not the experience of a heavenly host of angels with trumpets blaring, but something simple, humble even. An experience that lets the sublime slide in, even when sparked by the most humble circumstance, holds us speechless before it. Then, as artists, we must engage whatever we can to extract that feeling, isolate it and give it form. This can become divine work.

Our response to art comes from the power of the prayer that went into its making. The artwork lives. We respond. We can be more moved by a small intimate landscape or a still life of two cherries than by a huge painting of the Grand Canyon. Look at Chardin or Corot for instance.

The subject matter, a painting of Christ, for example, is not what gives a painting its spiritual substance. How deeply the artist felt, and how deeply we, as viewers, respond in kind, is what gives the painting its power and authenticity.

We may be moved by a painting's subject matter. But this might be a sentimental response. For example, one might be moved by a painting of a crying child but this is hardly what

I'm referring to as a poetic response.

In responding to a deep divine connection we respond to honesty, integrity and vulnerability. The artist may not be able to live that connection in their daily life, but in front of their easel, they are able to sustain an openness of being that becomes embedded in the artwork and we feel it.

When looking at paintings, most people are distracted by subject matter. But subject matter is really just an armature on which an artist hangs the blue and green hues or the abstract shapes, like notes of music.

The famous art historian Walter Pater said, "All art constantly aspires towards the condition of music. . . . For while in other kinds of art it is possible to distinguish the matter from the form [painted surface from subject matter] and the understanding can always make this distinction, yet it is the constant effort of art to obliterate it."

Vuillard, in the same vein, said, "There is a species of emotion particular to painting. There is an effect that results from a certain arrangement of colors, of lights, of shadows, etc. It is this that one calls the music of painting."

One painter may use the armature of portraiture, another, religious subjects or landscape. Someone else may employ pure abstraction. Each style or genre is just a means through which the elements of the painting sing with one another.

Each of us will be attracted to a particular kind of armature because it resonates with us. There will be certain shapes and colors and surfaces all our own. Our choice of subjects will be what allows this abstract language of paint to express itself.

In some paintings, say a Titian, the subject, the form, is so compelling, so good, that we have trouble separating the subject from the musical notes, the abstract response. That is due to the artist's genius. But the same principle holds true.

I once read a book about screenplay writing. The author's contention, and he was a well-known scriptwriter, was that there are only seven story lines in all scriptwriting. Every movie you see will fall into one of these seven. Unfortunately I didn't make a note of those seven story lines at the time. The idea seems intriguing to me now. But the point is that you don't need a lot of ideas to work with. If you have a few armatures that resonate with you, you can rework them over and over so you can go deeply into the poetry of the idea.

But you also need enough of an idea with which your spirit can connect. The area of interest some painters are engaged in, say, painting stripes in a limited palette, would bore me to tears before lunch. You need depth, but not at the expense of a range of subject that keeps you engaged. There needs to be a richness of consideration.

With a painter like Diebenkorn, his *Ocean Park* series is

clearly about the response to his color notes. There is for the artist a wonderful alchemy that happens between the poetic response to an idea and the poetic response to materials. Artists have as different a relationship to the use of materials as they do to subjects. Some hide the process, leaving no trace—Raphael, for instance, or Richard Estes. Others create a wonderful interplay of idea and surface, the poetry of subject mingled with its expression as paint. Think of Rembrandt or the late landscapes of Abbott Thayer. There is also the artwork in which the surface of the canvas itself becomes the potential for poetic expression. The *Ocean Park* series seems to have come from one idea: Matisse's *Open Window, Collioure* of 1914 melded with the southern California landscape. That one idea as armature was reworked more than two hundred times over the years by Diebenkorn. Some paintings were far more successful than others. But the one idea, the one armature, was enough to allow the poetry to sing, the divine to shine through.

I've mentioned that Kenneth Clark, the British art historian, said you could take the four best paintings of any artist in history and destroy the rest and the artist's reputation would still stand intact. This is because in any artist's life there are moments when everything goes right. The artist is so in tune with his or her inner vision that there is no restriction. The

divine is being expressed.

That experience of deep inner connection, that prayer of expression, transcends its material and becomes spiritual. The experience can be overwhelmingly joyful.

When on another occasion we can't reach that spiritual level of experience, the frustration can be cruel and the separation painful. Here lies the myth of the suffering artist. It isn't the art making when it goes well that has any suffering in it. It's the loss that causes the suffering. And the problem isn't something we can necessarily control. We are instruments, conduits for that poetic expression. It comes through us by grace.

The idea that we "make" art is perhaps a bit misleading. The final product is at its best the result of collaboration with spirit. We may be separated from a flow within our spirit for weeks. We continue to paint because there is no knowing at what precise moment it will return. And when it does we need our faculties alert and our skills honed. Then the poetry is everywhere.

■

PRINCIPLE SIXTEEN
Holding the
Big Picture

The most overwhelming problem faced by students and artists of all levels is keeping a sense of the whole of a painting as they work on the parts. In other words, the ability to hold on to the big picture. Painting effectively demands this adroit moving back and forth: seeing and engaging in the picture as a whole while focusing on the details of its parts.

When we paint, most of us use two types of visualization. The first is passive. This is the experience of seeing something and responding to it viscerally, deep inside, as something we want to paint. We can call it inspiration. We may need to spend some time with our chosen subject to really extract the essence of what we are responding to. But it comes as a feeling, whole. We just need to sort out what is giving us that feeling.

Then when we start to paint with that sense of the visualized whole somewhere in our attention, we start to commit to marks and strokes of paint that will represent it. We start the interplay between vision and realization. Then sooner or later we have the "ahhhhh, no" experience as we realize that what is coming up is not corresponding to what we had in mind. At that point we are engaged in active visualization, which is the feedback between what our initial inspired feeling was and what we now have on the canvas. There is now

a push and pull toward that initial visualization.

Several things can happen now, depending on the ability, sensitivity and experience of the artist. You can abandon the initial idea for what is currently suggesting itself. You can regroup and continue toward the original idea. Or you can, in a blind hope that things will work out, just keep applying paint to canvas.

The second possibility is usually the best. If you find the painting is slipping away from you as you work, stop. Regroup. Take stock. Remember the big picture you started with. Don't relinquish your vision to your brushes. Don't hope the brushes will somehow, if you just keep them moving, solve any problems for you. They are not very smart. If they are left to themselves, with a captain who is hoping they will lead, the painting will soon head for the shoals and run aground.

If you're feeling the direction you are going is moving farther and farther away from what you had in mind, sit back and look at your canvas. Learn to innocently watch where your eye is pulled.

The eye, in one sense, is a very simple instrument. It responds to contrast. The stronger the contrast, the more it responds. Innocently. In painting, you have three contrasts: that of value, hue and intensity. How light and dark something is, what color it is and how vibrant that color is.

In talking with students about a work in progress, I'm sometimes amazed at how hard it can be for them to see the repercussions of something they've painted. Shapes may appear too dark or too bright for example, or a passage off to one side is really busy. You might ask, Well, how can I decide what's too dark or bright—maybe that's what the artist wanted, or maybe it's more interesting than what my solution would be.

There are two reasons I think I can tell: First, the students aren't aware of what the offending piece is doing to their whole canvas. If they were, it probably wouldn't be there or they would be able to explain what they intend to do somewhere else or on top of it to balance it with the rest of the painting. But usually the student has no awareness of what I'm talking about. I put my hand over the offending color shape and then the student all of a sudden sees the rest hang together and realizes how disruptive the one spot was. They were proceeding blind and unaware.

Second, if you brought together ten experienced professional artists who were well respected as representational painters, put them in a room of fifty paintings done by artists of various abilities and asked them which were well painted, they would pretty much all choose the same ones. They might have very different ideas about which ones they personally

liked because of subject matter and method of painting. But on the question of whether the works were well painted or not, there would be almost universal accord. That's because the conventions for doing paintings are common. Once they have mastered them, any artist can tell whether another painter has a similar mastery or not.

And one of the most useful skills for mastering representational painting is to be aware of where your eye goes on the picture plane of your painting. This, I suspect, applies to most abstract painting as well, although on that subject you can get into some pretty questionable waters because the premises upon which the painting is based may be harder to decipher.

Where in the painting is the eye pulled? You can't craft a painting that carefully leads a person through and around your picture plane if you don't see it yourself. When the painting is well crafted in this manner, it is the result of a conscious set of decisions the artist has willed on the composition. If, when looking at a painting, a viewer's eye is drawn to a dark line of bushes on the bottom left-hand side, rather than being pulled into the heart of your composition, you obviously have a problem.

So how do you solve the problem? First, spend time looking at your paintings while you do them. Most paintings need

to be painted from viewing distance, not from up close. I don't mean you need eight- to ten-foot brushes but that you look at the painting from its viewing distance and then go forward and make the necessary adjustments. Then you step back again and see what the painting needs next. Looking at it upside down or in a mirror also helps you to see it fresh. Shapes that are too dominant or lines of direction that you weren't aware of have a way of jumping out at you.

If you're finding yourself trying more and more drastic means to solve something that clearly isn't working, stop. Stand back and spend time with it. Cover up parts of the painting with your hand, or step ten feet back and see if you can locate the offending part. Often there will be one major flaw in the overall composition that is setting the whole design into disarray, and until you find that flaw no amount of tinkering with the other parts is going to help. They will just slowly drive you mad as you go round and round, repainting and repainting different parts until you are completely discouraged. So stand back and spend time at a distance from your work, looking at it.

There are two very useful exercises to enliven this skill. One is to spend more time doing thumbnail sketches before starting to paint. Give some thought to what needs to be simplified, where you want to lead the viewer's eye, where

you want them to end up, how you'll guide their eye there. There are so many problems to solve in making a good painting that to stop and make a road map before you start gives you an idea of how you will proceed and also helps you identify when you've arrived. The old masters used to do a grisaille before they started to paint. They were probably doing a multi-figure composition and knew how devilishly difficult it was to get everything to work and not have some confounding and distracting element appear. So they would do the whole painting in black and white first. That way they could be sure they had solved a lot of the compositional problems at the outset.

So if the old masters recognized the need for some careful preparation, we could probably follow suit. Of course you've seen the x-ray photos of old master paintings that show figures removed and elements of the painting drastically altered. I'm not saying you should create a road map and not deviate from it. Their changes indicate that even with careful preparation there are things that happen that you couldn't have foreseen, sometimes for better, sometimes for worse, and you need to adapt to them.

However, without some guide as to where you hope to go, you will be relying largely on luck and wishful thinking to get to your destination. I have said this over and over to

students out landscape painting and its importance doesn't seem to register quickly: "Gotta get the brush in the paint." But if you will spend time with a thumbnail before starting, it will significantly improve your chances of success. What we conceive well, we can express clearly.

Once you've got the thumbnail you need to be attentive to getting the idea, particularly the major proportions of the sketch, to the canvas. So many times I've seen a carefully drawn thumbnail get redrawn onto the canvas in completely different proportions. The effect of the original idea is either lost or very watered down before the painting is even started. Usually the student is surprised when I point out what he or she has done. The proportions of your canvas are the four most important lines in the composition. If you don't notice that the proportions have changed, that's one thing. But if you do realize it, and say, "oh, well," you've pretty much doomed yourself from the start. You have to care about the details of the process if you ever hope to go through everything it takes to produce a result that will have an impact on anyone else.

This reminds me of the Renaissance painter, Andrea Mantegna. Some people say Mantegna was a genius because he repainted the head of Christ a hundred times before he captured it the way he wanted. Others say he wasn't a genius

because he had to repaint the head one hundred times before he got it the way he wanted. Either way, he obviously cared. He was passionate about working at it until it felt right.

For some artists, this may all sound too contrived and tight. They admire loose painting. But some very loose painters engage in more preparation than you would imagine to create a painting that works. The preparation is done in advance, and then on that foundation the artist will wail away.

Finally, a great exercise to develop and train your eyes to greater sensitivity to the picture plane is to draw paintings that move you. Do not be fastidious about it. The drawings should be small, three inches by four inches or four inches by five inches, in pencil, which is a very fluid and responsive medium. Draw the main shapes, see the way your eye is being moved around the picture and what devices the artist uses to do that. Notice how there are primary and secondary lines of motion around the composition and how they keep you inside the picture plane and make sure you're not pulled outside of it.

Or perhaps, if you do get thrown out, note why this happens. Start by looking at Titian, Brueghel, Vermeer, Rembrandt, and Rubens and you'll get the idea. Choose paintings that intrigue you. Spend time with them. See if there is an

underlying geometry to the way the artists have divided the canvas and created diagonals. Focus on a few paintings. This is a great exercise to do in a museum.

The best way I've found to view a museum is to go early and walk easily and fairly quickly through all the sections that interest you. Choose the three or four paintings that most arrest you. Then go take a break. I don't think you can look at paintings for more than an hour and a half, two maximum, without going brain dead. And you can waste all your mental energy just walking dutifully around giving attention to each piece. When you come back, study and draw just the three or four you selected. Doing this exercise of drawing a painting, studying its shapes and proportions, engages us far longer in the learning process than when we just look at it passively.

Composition is the wholeness, the thing that coordinates color, form, value, everything. That's the vision, the big idea. Everything plays to it. As Paul Valéry, the French poet, said, "To see is to forget the name of the thing one sees."

■

Conclusion

My father was a painter, and many of his friends were painters. They were all landscape painters. They would go on painting trips to Gloucester, Massachusetts, and into northern Ontario. And from the age of ten or so I'd go with them and paint too. They would critique my work along with theirs and it was a great education. But they fitted into quite a tight mold of representational painting. My father in particular could be harsh at times in his criticism. So having a painter for a father was a blessing and a curse.

What I gained from this early education was an ability to "see" a composition, to select it out of the mass and jumble of stuff in the world around me and convert it into a workable painting. The means to express that composition also appeared at the same moment. Both the vision and the conventions that would enable me to produce it were simultaneous. This was the blessing. However, once you start a painting that way, you are going to get a result that continues to match what you have done in the past. One painting may realize it more successfully than the next, but the end result is largely dictated by the conventions that predicated the start. This was the curse.

I followed this method, painting after painting. Sometimes for a while I would explore other avenues but I always came back to this method and the need to master it.

About three years ago I was in northern California painting every day for about a month. Doing painting after painting, I was "in the zone," with compositions, execution, focus and energy. One morning I was painting an old Cadillac in a friend's backyard. It was a complex subject with wonderful light and reflections. Each mark I made seemed to pass effortlessly from my eye through my brain down my arm and out the end of my brush onto the canvas. I could do no wrong. And sometime during that painting something clicked—the feeling that I know how to do this. I don't need to prove it to anybody ever again because I really know how to do this. As I had this realization I could feel a physical sensation release from my body. I was free of it. Perhaps that whole parental mold of art making was gone.

The release was deep, way down in the psychology somewhere. And I realized this effortless connection that I was experiencing while painting the Cadillac all of a sudden had changed something. Everything was still aligned, except for the deepest, most profound level, which had just shifted as if to the right, half a foot. And I realized that this was going to change everything. I didn't know when or how but it was

going to change my relationship to art and why I make it. It would release me into a much deeper connection to my motivations for wanting to make art. The art was going to get more authentic.

I continued to make paintings that weren't that much different from before for about two more years. I pulled out of the three galleries I was exhibiting with because I didn't want to continue to satisfy gallery requirements or input while I was trying to figure out where I was going artistically. I started working quite a bit larger on location, just because I didn't yet know what else to do.

Then a year ago I started working much larger with more vibrant color. A very good gallery saw that work and immediately wanted to show it. I did a number of paintings for them. But this was not really ringing true either.

At the same time I realized it was time to take a break from teaching the plein air painting workshops I'd been doing the past ten summers in Provence and Tuscany. I knew I would return to teaching but, at this specific time, I needed to focus more on my own work.

Now, finally, the direction of my artistic evolution is becoming clearer and getting very exciting. At least to me. What you put your attention on grows stronger. By eliminating the things that no longer held me I was able to put

enough attention on these delicate sprouts that wanted life, expression.

Art, as I've said, gives us tools for growth. The more sensitive we become to listening to the subtle ideas that emerge from deep within us and the more courageous we are in acting on them, the more we get in touch with our Self, our soul, or spirit, and the more aligned we are with why we are here, on this earth.

Although the new direction in which I am currently immersed is still very much on the drawing board, so to speak, if you are interested in its form and expression you can keep abreast of its development at *www.ianroberts.us*.

As for you, I hope the ideas and suggestions here have in some way encouraged, inspired or motivated you to give voice to who you are and to respect what it is you authentically want to say. God bless.

■

Notes

SEARCHING FOR BEAUTY

1. Ken Wilber, *The Eye of the Spirit*, Shambhala, 1998, p. 136.

2. Rollo May, *My Quest for Beauty*, Saybrook, 1985, p. 229.

3. *L.A. Times* magazine, Dec. 8, 2002, p. 18.

4. *A Companion to Aesthetics*, edited by David Cooper, Blackwell, 1995, p. 44.

5. *Uncontrollable Beauty*, edited by Bill Beckley, Allworth Press, 1998, p. 268.

6. David Whyte, *The Heart Aroused*, Currency Doubleday, 1994, p. 293.

7. Wendell Berry, *Sex, Economy, Freedom and Community*, Pantheon Books, 1992, p. 112.

8. *The Heart Aroused*, p. 287.

COMMUNICATION

1. *Emerson's Essays*, Perennial Library, 1926, p. 254.

2. *The Heart Aroused*, p. 91.

THE VAN GOGH SYNDROME

1. Pierre Cabanne, *van Gogh*, Thames and Hudson, 1963, p. 220.

2. Ibid., p. 263.

3. Mihaly Csikszentmihalyi, *Creativity*, Harper Collins, 1996, p. 19.

YOUR CRAFT AND YOUR VOICE

1. David Bayles and Ted Orland, *Art and Fear*, Image Continuum, 1993, p. 55.

2. Ben Shahn, *The Shape of Content*, Vintage, 1957, p. 35.

3. Pete Schjeldahl, "Notes on Beauty," *Uncontrollable Beauty*, p. 54.

SHOWING UP

1. *Kindred Spirit* magazine 56, Autumn, 2001, p. 9.

2. *Emerson's Essays*, p. 235.

THE DANCE OF AVOIDANCE

1. Audrey Flack, *Art and Soul*, Penguin, 1986, p. 136.

WAGON TRAIN AND SCOUT

1. *L.A. Times* magazine, p.18.

2. *The Shape of Content*, p. 82.

WORKING METHOD

1. André Malraux, *The Voices of Silence*, Princeton University

Press, 1978, p. 117.

2. *Art and Fear*, p. 4.

3. Irwin Edwin, *Arts and the Man*, W. W. Norton and Co., 1939, p. 15.

4. *The Eye of the Spirit*, p. 136.

5. Eric Maisel, *Deep Writing*, Tarcher/Putnam, 1999, p. 19.

LIMITS YIELD INTENSITY

1. Brenda Ueland, *If You Want to Write*, Grayworl Press, 1938, p. 26.

2. *My Quest for Beauty*, p. 209.

3. *The Voices of Silence*, 1978, p. 353.

FOR MORE INFORMATION

on workshops, books and videos,

and to see paintings by Ian Roberts,

go to www.ianroberts.com

∎